akiane her life, her art, her poetry

·		
	*	

akiane her life, her art, her poetry

akiane and foreli kramarik

© 2006, 2017 by Akiane and Foreli Kramarik

All rights reserved. No portion of this book may be reproduced, stored in a retrieval system, or transmitted in any form or by any means—electronic, mechanical, photocopy, recording, scanning, or other—except for brief quotations in critical reviews or articles, without the prior written permission of the publisher.

Published in Nashville, Tennessee, by Nelson Books, an imprint of Thomas Nelson. Nelson Books and Thomas Nelson are registered trademarks of HarperCollins Christian Publishing, Inc.

Thomas Nelson, Inc., titles may be purchased in bulk for educational, business, fund-raising, or sales promotional use. For information, please e-mail SpecialMarkets@ThomasNelson.com.

ISBN: 978-0-7180-7586-6 (new edition)

The Library of Congress has cataloged the earlier edition as follows: Library of Congress Control Number 2005033687

Previously published under ISBN 978-0-8499-0044-0

Printed in the United States of America 17 18 19 20 21 LBM 6 5 4 3 2 1

I DEDICATE THIS BOOK TO THE CREATOR

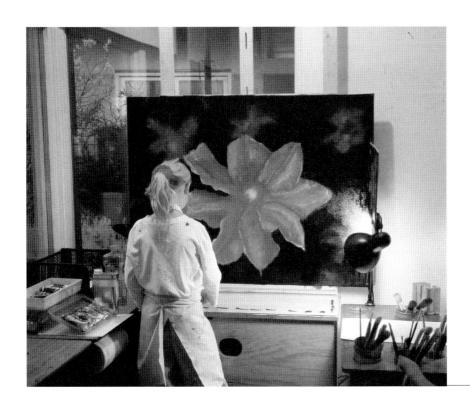

contents

Part One: Akiane: Her Life • I

Part Two: Akiane: Her Art • 41

Part Three: Akiane: Her Poetry • 89

AKIANE

akiane her life

Akiane at 3 months old

The First Years

Two weeks overdue, but exactly on the destined due date, our daughter was born as a hot, muggy July day dawned over our home. Like millions of other parents, we felt that there had to be some Higher Power behind this wonder, but at the time we did not suspect the spiritual transformation that our family would experience due to the influence of this nine-pound baby girl.

After her underwater birth, we held her in the warmth of the birthing pool as she looked up at us with her blue eyes. Through the ripples we could see her long hair floating in the water and her delicate fingers occasionally grasp the pulsing umbilical cord. My husband, Markus, cut the cord, and we named our newborn after the Russian word for "ocean": *Akiane*.

"She will have bright eyes," he noticed.

"She will be a picky eater!" I said as I observed the way she suckled.

Relieved that the home labor had passed without serious complications, we were elated to kiss and rock our third child. The midwife had come, but only to tell us we needed to pay her. And so it was that Akiane came into the world on her own.

We had recently moved from Chicago to the small town of Mount Morris, Illinois, and the only place we could afford was a shack on the edge of a cornfield. Outside of the house we felt no safety; one neighbor was murdered, another caused fire after fire

by burning trash next to our windows, another tried to shoot our dog, and another threatened to assault us if we didn't attend church. The interior of our house was unpleasant as well. The walls and flooring were cracked, moldy, and splattered with paint, and no matter how much we cleaned and scrubbed, the place was unsightly. We didn't have much furniture: one bed, one table, one chair, one rocker, and one empty bookshelf. There was no sink in the kitchen, so we washed the dishes in the bathroom or in the foul-smelling, flooded basement. But somehow none of this bothered us much, for we were busy talking, laughing, and playing. I was able to be with the children all the time, and they received my complete attention.

One day, while climbing the steep and crumbling concrete stairs outside our home, I tripped, and since there was no railing, fell. Three-week-old swaddled Akiane fell out of my arms and landed right on her face, straight onto the hard asphalt. The fall was terrible! I was sobbing along with my little baby, whose face began to swell and bleed profusely.

Akiane cried all day long. That evening we received a strange call from Europe telling us about a certain woman named Victoria, from the mountains of Armenia, who was telling many people about the incredible future of a girl named Akiane. A little later she called us herself and, with a thick Russian accent, tried to verbalize the spectacular events that were ahead for our daughter. Since she was a Christian and we were not believers, we did not take her passionate talk seriously, letting it go in one ear and out the other, completely rejecting it. Nevertheless, from that strange phone call we took the hope that our daughter would not be affected by the trauma of the fall that morning. Maybe that was all we needed to hear. The next day Akiane stopped crying, and her face began healing rapidly. After the incident we never again swaddled her but kept her close in a sling or a baby carrier.

With her frequent giggles and sunny personality, our newborn brought joy to all of us. She was very affectionate, sensitive, observant, and shy.

Our family led a fairly simple life; Markus commuted a long distance to work as a chef while I stayed home with Akiane and her two older brothers, Jeanlu, two, and Delfini, four. With little money and no friends nearby, we had to create our own fun. Every day I would dress our children warmly and take them across the cornfields to watch the sun set over the nuclear power plant that was visible on the horizon. We spent hours counting the birds in the sky and guessing which direction the steam from

the plant would drift. At home we made a swing for Akiane, where she spent many hours rocking and napping. The boys grew monarch butterflies from cocoons they found in the meadows, wrote their own books, and turned tree branches into swords. They made wreaths from flowers or pine needles, play-dough from flour, tents from blankets, and forts from cardboard boxes or snow.

The children and I made carrot pancakes and almond cookies to share with the neighbors, but although we knocked on doors to invite our neighbors over for tea or dinner, we realized that no one was interested in getting to know us. Almost every day we walked a few miles to the playground in hope of meeting playmates for the children—or anyone with whom we could share a conversation. But everyone seemed content with their own social circles.

Our daughter learned to crawl and walk very early, and after taking her first steps, she was very deliberate in every move, rarely falling down. The only delay in her development was talking, as she preferred to listen and would say only a few words. She always chose to observe new places and families from a safe distance before engaging in

any direct interaction, and since the playground suited her personality, it soon became her favorite place to meet new faces, challenges, and adventures. Akiane liked to stay there half the day—even on chilly days—so we always packed books, blankets, and plenty of food.

My husband Markus's long work hours and severe pesticide poisoning eventually wore him down. With severe asthma, his health began to deteriorate. When he took on a second job to help make ends meet, the combination of stress and asthma caused him to lose weight rapidly. Without money to see a doctor, he began to fear the worst. I would often hear him say, "I might not last long. Please, think now about how you—by yourself—could support our three children. There's no one to help us, and I am too weak . . . I don't know how much longer I can go on."

Akiane at 18 months old

Although I cherished my time with the children, because of the heavy burden of poverty and sickness in our family, I became involved in a sales business that, surprisingly, began to flourish very fast. At home, in the same room where our three little children played, I reluctantly learned about the outside world.

As a toddler, Akiane paid close attention to textures and fabrics. She loved to bring

home rocks, shells, leaves, and flowers. When we went shopping or out to meet people, she insisted on touching each person's clothing and feeling the different textures of skin. Since she was a very tactile child, we brought her a live bunny from a farm, and

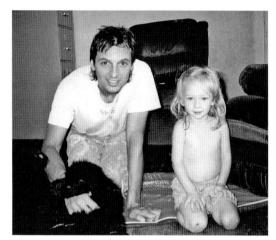

Akiane and her father

then a black Newfoundland puppy, which she loved feeding, training, and grooming. Her fascination with living creatures was apparent even then.

Akiane was unusually sensitive to the moods of those around her. She was quick to sense someone's essence, even through the thickest masks of laughter and smiles. "That woman is bad," she might observe—even if it was the exact opposite of what Markus and I had perceived. And if we left her with someone she didn't like for even a few minutes, she wouldn't stop crying until she was back safe in our laps. Surprisingly, her first impressions of people proved accurate time and time again.

By the time Akiane was two years old, my sales business had become so lucrative that we earned enough bonus money to purchase a house. I reached the top position in our nutritional product company, and after receiving an award and a sizable check, we packed our little white truck and drove from state to state looking for a new home.

We finally found a home in the state of Missouri, a ten-thousand-square-foot replica of a Frank Lloyd Wright house situated by a lake on a golf course, at an unbelievable bargain price. The children especially delighted in the new place. They often jumped off a trampoline into the twenty-foot diving end of our indoor pool, chased a cleaning robot, and warmed up in a sauna or a huge hot tub. They spent endless hours riding their bikes down the long hallways, fishing in the backyard, and playing hide-and-seek on the flat roof.

Our new financial situation also allowed us to buy fresh organic food, and our children were able to eat fruit as often as they liked. We frequently enjoyed lobster, freshly baked bread, avocado smoothies, and coconuts. We could also afford advanced medical care, but even this did not improve Markus's health, as the humidity in Missouri only exacerbated his asthmatic condition.

After a year, the thrill of the large house had died down, and we realized that we'd

made a huge mistake. We just didn't need all of that space. In fact, we didn't even call it our home anymore; we jokingly called it "the Frank Lloyd *Wrong* house," "the sanatorium," "the Pentagon," or just "the hotel." And so we resolved to hire a Realtor and put it up for sale. With shoes neatly lined up by the door, with towels perfumed in the bathrooms, with the slate black tile floor polished to perfection, we had one showing after another—but no one was interested.

Akiane at age 3

Dreams and Drawings Begin

Before we could fully comprehend what was happening, I found myself in the sinkhole of the business world. Although Markus helped me with office duties every day and I was able to work mostly from home, I felt that there was increasingly less time left for my children. I was pulled between the business and the family. Money didn't seem to bring us more happiness; instead, my work was clouding the joy of motherhood that I had once experienced.

Because Akiane and her brothers had only a few acquaintances and had never formed deep relationships with anyone outside the family, they played mostly with one another. Our family never talked about religion, never prayed together, and never went to any church. I had been raised as an atheist in Lithuania, and Markus had been raised in an environment not conducive to spiritual growth. The children did not watch television, had never been out of our sight, and were homeschooled; therefore, we were certain that no one else could have influenced Akiane's sudden and detailed descriptions of an invisible realm. We can't remember the exact month, but one morning when Akiane was four, she began sharing her visions of heaven with us.

"Today I met God," Akiane whispered to me one morning.

"What is God?" I was surprised to hear this. To me, God's name always sounded absurd and primitive.

"God is light—warm and good. God knows everything and talks with me. Like a parent."

"Tell me more about your dream."

"It was not a dream. It was real!"

I looked at her slightly puffed eyes, and in complete disbelief I kept on asking her questions. "So who is your God?"

"I cannot tell you." Akiane lowered her head.

"Me? You cannot tell your own mom?"

"The Light told me not to." She was firm.

"Akiane, darling, you can share anything with me. You know I won't tell anyone."

"Yes, you will. You cannot know."

"Why did you think it was God?"

"Just like I know you are my mommy, and you know I am Akiane."

"Who even taught you such a word God?"

"You won't understand."

I was astonished to think she felt she could not tell her own mother. Even more puzzling was the fact that she had learned the word *God* on her own. Upset and uncomfortable, I suggested that maybe it was a nightmare and that if she would just

talk to me, I could help.

I begged her that whole day to tell me anything at all about her dream, but she never gave in. About six weeks passed before I succeeded, finally reaching a point where she would describe to me details about different worlds and the future of the earth. We no longer suspected she was imagining such events, because she had never fantasized like other children her age. She never initiated pretend games, talked with imaginary friends, or visualized living in other places as so many young girls do. With her matter-of-fact approach to life, she always took play and

Foreli and Akiane in front of their home

work very seriously, preferring everything to be real. She simply had no interest in fairy tales, fantasies, or anything artificial.

Now she began to share these new experiences, which were unlike anything we were accustomed to hearing. The smallest details, the predictions, and the sense that she spent more time away in the spiritual world than with our family were all hard to ignore. Sometimes she sounded like an older woman—not because of her voice, but because of her total sincerity, her strangely compelling comments, and her broad vocabulary. It scared us and inspired us at the same time.

Though I had promised I would not tell anyone, I did not keep my promise to her. Since I burned to share her stories with others, somehow, little by little, I started relating them to a lot of people. I was giving away Akiane's secrets. But it was premature; what Akiane knew and saw was not meant to be known or disclosed, for neither I nor others were able to handle the messages at that time. I learned when Akiane shared

these dreams and visions, which to her were actual life experiences, to stop telling others. I simply began recording them in a journal.

About the same time as the visions began, Akiane suddenly began showing an intense interest in drawing. She began sketching hundreds of figures and portraits on whatever surfaces she found at hand, including walls, windows, furniture, books, and even her own legs and arms. The different poses were drawn mostly from her imagination. Sometimes she scribbled and sketched with her eyes closed, and sometimes with her pencil between her toes or her teeth. There were also times when I would find our white walls smeared with charcoal from our fireplace or with fruits and vegetables from the garden. And sometimes after a reprimand she would scribble on the bottom of the tables so we would not see her mischief.

One day we noticed white spots on her front teeth. We asked what had happened, but Akiane just turned away.

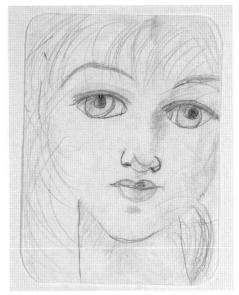

Akiane's angel, drawn at the age of 4

"Akiane ate a tube of toothpaste," Delfini accused. "Her angel's teeth are so white, they sparkle. She thought that if she ate toothpaste, her teeth would also get whiter."

The next morning, after unscrewing almost the entire bookshelf to make an easel, Akiane woke me up at 4:00 a.m. by waving a drawing of a woman over my face. "Look! This is her—this is my angel," Akiane explained. "Her skin is so smooth, not one spot. She doesn't smile in my picture, because paper is not white enough to show how white her teeth are, and I wanted to show how she talks to me with her eyes and teaches me how to draw."

Our four-year-old daughter was most inspired by faces, and she would sit for hours drawing, erasing, and shading their features. For the next two years, the walls of our home were filled with sketches of her family, her acquaintances, and faces that she dreamed about. At this point she didn't work with colors; she asked only for lead pencils and charcoal.

Akiane seemed unusually patient and serious for one so young, totally dedicated to her work. Not a perfectionist in any other area of her life, this intensity of focus came as a surprise to us. She'd leave her room untidy or her hair uncombed, but her portraits always had to be absolutely perfect.

Her images were often very perceptive. Once, when Akiane sketched the portrait of

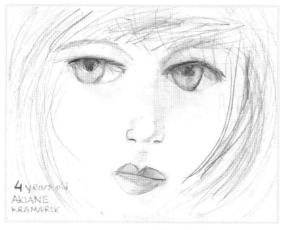

"My Mother," drawn at age 4

a woman who seemed to be very happy, she depicted her subject with a very sad expression. Upon seeing the picture, the woman tearfully admitted that her happiness was a front, for she had just lost her only son. Another day she showed me a sketch of myself looking to the side. "You look away from me and my brothers! I want to be with you more . . . You spend all your time in your office and have no time to play chess with me. We need each other. We need kisses."

One summer afternoon Akiane ran around the house feeling all the glass, tiles, stones, and walls that she could get her hands on. After being unable to find any material that matched what she wanted to describe, she sat quite

disappointed on the tile floor and started sketching a series of concentric circles with a candle on the pool window. "Oh, no, I can't find it here. I can't show you the house of Light. I wish you could see it. It's so beautiful and so big! It looks like circle, circle, circle, circle inside circle, circle, and circle . . . Walls like glass, but not glass. Water pink, purple, and many other colors I can't find here. Trees and grass are not green there. There are . . ." She ran outside and promptly returned with a fuchsia flower. "Close to this color. There I plant a tree, a big tree. It has yummy fruit."

"What fruit?"

"It tastes good, better than anything you've ever tasted. The Light gives me fruit."

"For what?"

"To breathe."

"What do you mean?"

"To live. I plant that big tree. You will eat it too."

"Why me?"

"I don't know. I was told that many will need to eat that. The tree will always be there on a new earth"

"What else do you remember?"

"I eat there, but I don't go to the bathroom. The plants there move and sing when I move and talk. It seems as if they can think. Animals there are not like here. They listen to me, and they're not afraid of me, so I can pet them whenever I want. Some of them create the most amazing plant sculptures. I also fly on top of huge birds there while I am strapped inside a cage that looks like this." She touched a diamond inside my wedding ring. "I am good there, and I listen there. Everyone listens there."

Slowly and cautiously, Markus and I tried to logically fathom the realm our daughter was sharing with us, but we just couldn't do it. We had to either take a leap of faith or remain locked up in skepticism and doubt. The leap was not a step and not a climb—it was a direct fall. We didn't know what was below, but we had a hunch that it wasn't worse than where we were standing.

When Akiane was four and a half she started showing great interest and talent in gymnastics, but when she found out that all professional gymnasts suffered through quite a few injuries throughout their careers, she had to make the difficult decision between art and gymnastics. After giving this plenty of thought, she chose healthy hands for her art.

Then she started dancing. She danced on the couches, on chairs, and in bathtubs. She danced in front of a mirror and in front of our family and guests. Greatly intrigued

AKIANE'S DRAWINGS AT AGE 4

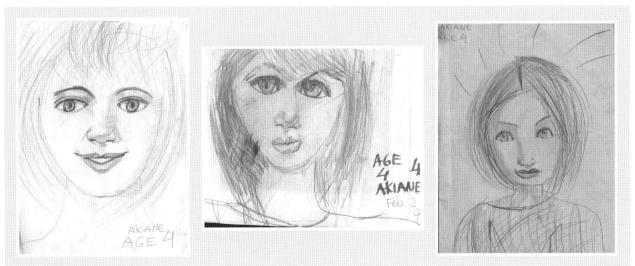

by movement, physiology, and anatomy, our daughter was now inspired to be a ballerina and a doctor. Anything relating to health, the human body, or behavior simply intrigued her.

But there were few things harder to understand than Akiane's response to music. For her first five years, she would start to cry every time any kind of music was played. Later, when she was able to talk, she would beg us to stop the music—and no one had the slightest idea why. One evening after another similar confrontation, I broke down. I simply couldn't understand her. As I sobbed, I felt small hands raise my wet face, and I barely heard my five-year-old's apology.

"Mommy, please, please, don't cry. I'm sorry I act this way, but the music that I hear in heaven is better than here. This music hurts my ears and my head really bad, but heavenly music is always gentle. I can't tell you how different it is from what you hear on earth! It feels like joy, looks like love, smells like flowers, and dances like butterflies. Music there is alive! You can even taste it."

More and more, Markus and I were confronted with Akiane's independent thinking, so we took steps to understand her and her faith. Our embryonic perception of Divinity, however, was still very frail, and during any hardship we would slip back to our own tangible and logical world full of proofs and questioning. We could marvel at

AKIANE'S DRAWINGS AT AGE 5

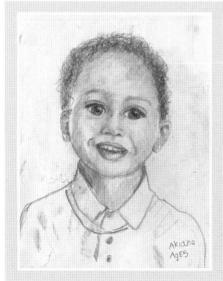

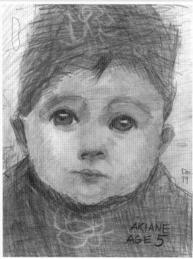

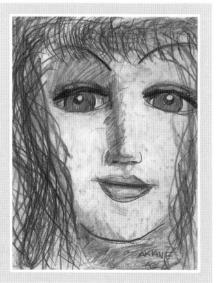

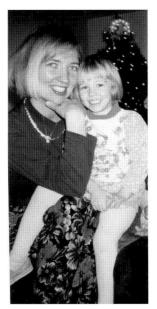

Akiane, age 5, and her mother

Akiane's faith, but we had to start somewhere for ourselves. Inspired by her spirituality, and for the first time ever, Markus took the family to visit a few different churches. But what we found seemed to be a place for adults and not children.

As we continued to assemble the Akiane puzzle, we decided that I should quit my job and once again devote my attention to our children full-time. Unfortunately, after I resigned, Markus couldn't find a decent job for a number of months. Our huge home had been on the market for a long time already, and soon we began living as if we were in a hotel without occupants, draining our entire investment.

"We need to stay here longer. When it's time, we will sell." Akiane tried to comfort us with each passing month,

but our financial troubles were growing. We had to sell our furniture, the car, the play-grounds, and our library of books. We were able to bring in a small amount of money by organizing a place for other children to draw, but our family continued accumulating

AKIANE'S DRAWINGS AT AGE 5

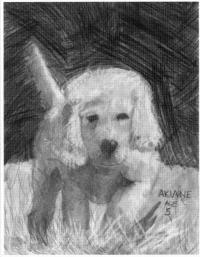

heavy debts just to stay afloat. It seemed so odd that we owned one of the largest and most famous residential houses in the county, but we drove an old, rusty pickup truck, ate canned beans, washed our clothes by hand, dusted empty bookshelves, and cooked potatoes in the fireplace.

Yet at this point, because of our newfound belief, we were even more drawn to God. For the first time in our lives, we were experiencing indescribable joy, harmony, and peace.

A New World of Color and Words

Despite our financial plight, we were impressed to have a fourth child—a deci-

Brother Jeanlu and Akiane, age 6

sion that led to another difficult pregnancy. I was confined to my bed and suffered severe, round-the-clock vomiting, and if I had to leave the house, it was always with the aid of my husband and a wheel-chair. Because of the challenges we faced during this time, we felt that we could no longer school the children properly ourselves. We assumed that a religious school would be most suitable for our daughter's spiritual inclinations, so we sent the children to a parochial school that, due to our circumstances,

offered us free tuition. Although Akiane enjoyed the structure, the studies,

and the friends she'd made in her first-grade class, she often complained about the noise. By the time she finished her classes and came home for the day, she was inclined to rest and had very little energy left for art.

As busy and sick as Markus and I both were, we gradually began to recognize Akiane's unique talents. We had more questions than answers about her dreams, though at that time we were only comfortable sharing with others her

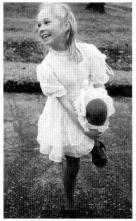

Akiane at age 6

unusual gift for art. One day at the craft store, Akiane spotted a box of oil pastels. Although she'd never seen or touched any before, she announced, "I think I am ready

to paint in color." At home she immediately began to explore the new medium that we had purchased for her, rubbing her fingers between the sticks to blend them. The world of color was now wide open for her, and the more she worked with it, the more confident and joyful she became.

On one occasion, Markus and I asked Akiane and her friends to participate in a county art competition. She was the youngest contestant and didn't even win a ribbon. The jury simply told us she had no talent. We tried to support Akiane by displaying her drawings at local art and craft fairs, only to

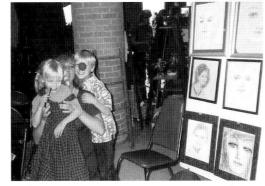

Akiane, brother Delfini, and mother at a local art show

be disappointed again. Most people doubted that a six-year-old could be so artistically advanced; they refused to believe our daughter had actually created the pictures.

"Mommy, how come no one looks at my drawings?" Akiane asked me sadly during her first show. "Look, the teachers of my school have just passed. I saw a librarian and the banker. Have you seen how they looked at our stand?"

"How?"

"Without any 'wow.' Without any interest . . ."

Barely attached to the display wall with pushpins, Akiane's drawings were flapping in the wind. We couldn't afford frames.

"Akiane, I just don't know why their eyes aren't on your art."

"One day . . . one day it will be different, Mama. One day it will change."

That spring, in the same inflatable pool we had used for all the underwater births, we had an eleven-pound boy. The minute Ilia was born, the vinyl pool burst, and water was all over the floors and carpets. All three children were in the family room at the time of the birth, so immediately following Ilia's

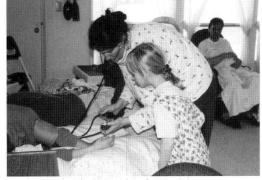

Akiane attending to her mother after her brother Ilia's birth

arrival, they poured into the master bedroom. In no time, they were able to hold the plump newborn. Now that Akiane was no longer the youngest, her mannerisms and intonations seemed to instantly mature.

A few months before the school year ended, our family was on the brink of declaring bankruptcy. Since Realtors hadn't been able to sell the house in almost four years, even at a significantly reduced price, Akiane suggested that we try to sell the house ourselves. We felt we had nothing to lose. Surprisingly, we were able to find a buyer the very next day. Then almost immediately, Markus found a job in Boulder, Colorado, and we found ourselves moving into a brick house on the slope of a mountain.

Seven-year-old Akiane began attending second grade at a small mountain school. Unhappy about her studies and her high-altitude headaches, she begged us to take her out of public school and to move somewhere else. That year proved to be a disastrous year for the entire family—Mark and I were very sick; my parents, who lived in Europe, nearly died; Delfini was scalded by boiling water and airlifted by a helicopter to a Denver hospital; Jeanlu injured his leg; and Akiane's finger was accidentally severed by a closing door and then sewn back on. While we were dealing with one accident after another, Ilia, the baby, was developing a life-threatening autoimmune dysfunction due to environmental toxins that caused him to become severely allergic to everything he ate, touched, or breathed, with open, deep, oozing sores all over his body that bled every day. Between the ambulance rides and nursing a sickly baby, it seemed as if the plague of worries would never leave us.

Although the children attended public school, I gave them the assignment of composing a few poems, a family tradition from my home country.

"It's finished!" After a few days had passed, Akiane was the last of our children to put her handwritten poem on my lap. "But why do we have to have homeschool assignments after we come from school? It's so tiring!"

I couldn't read a word. Everything looked totally illegible and messy, so I had to ask her to read it to me. Even she could barely read her own writing, and with so many other things on my mind, I just couldn't focus on what she was reading. In order to understand the poem, I decided to write down what she was saying. Still, with our one-year-old son crying and babbling, I didn't give much attention to what she was dictating. After I changed a diaper, I grabbed the crumpled sheet of paper on which I'd written and finally focused on Akiane's poem. As I thumbed through it, scrambled with both Lithuanian and English words, I was flabbergasted.

Searching for Rainbows

Blind secrets feel the frozen bells Whistling through the caves To become heroes in God's army Have we stood up like caged-up slaves

Harps burn like prisoners in brimstones
The sunset closed the garden gates
The razor jealousy has splintered promises
The foot traps locked our mistakes

We leave thirsty from the lifeless feasts While royal crowns collect the dust The empty hours steal the sweat of time When we believe—who heals our trust

Like color-blind ospreys searching for rainbows
We search for divine strength alone
Covered with wasps we walk in God's shadow
If we die with the smile—we journey home

Having put Ilia down for his nap, I rushed to the bathroom where Akiane was singing off-key in the shower. "How did you do it?"

"It just came to me!" Akiane answered with a mouthful of water.

"What do you mean it just came to you? Did you copy it from anywhere?"

"No!"

"Wait, wait . . . did you memorize it from anywhere?" And then I stopped there, remembering how difficult it was for her to memorize anything. More than once I had quit teaching her Russian simply because she could not remember new words.

"Mom!" She opened the shower curtain. "I promise, I wrote it on my own. You can ask Delfini. He saw me writing."

"I believe you . . . It just sounds too amazing to believe. What is your poem about?"

"Aha! You have to figure that out by yourself."

"What do you mean?"

"Well, if I told you what I wrote, there would be no mystery or adventure."

"So, tell me from the very beginning how you created it."

"Honestly?"

"Honestly."

"Well, I really had no ideas for a few days. But then I closed my eyes, and all of a sudden I started seeing the words and images right inside my head. It's weird, but it happened. Honestly, I don't even know the meaning."

"Do you think it can happen again?"

"I don't know."

As I was rereading her thought-provoking poem, I started to sob. Her composition astonished us, especially knowing that Akiane always had quite a challenging time with languages. She was not articulate and didn't enjoy reading at all.

Akiane now began to either handwrite poetry or dictate it to me, often creating a poem effortlessly within seconds—a poem that needed no editing. Each poem seemed as dynamic and flawless as the next. There was no trance or automatic writing involved—we had no idea how she did it. We did know, however, that it was happening consistently every week.

Up until that time Akiane had read only nursery rhymes, so the source of the unique imagery, rhythm, and aphoristic wisdom in her poetry was a mystery to us. We observed her working and witnessed the evidence of her spirituality, but we could only guess and wonder at her intricate connection to the unknown.

Strangely enough, she never spoke of her poems. At least at the beginning, writing was something she was totally indifferent about. It was like combing her hair—something she needed to do, but it wasn't of great importance to her. With the passing of time, Akiane felt more and more compelled to write, remaining completely oblivious to the maturity of her compositions. Often she would include words in her poetry that neither Markus nor I knew the meaning of. Some of her words, as it turned out, weren't in dictionaries, because they were combinations or composites of words that created new meanings.

Interestingly enough, Akiane was never drawn to read the works of other writers.

"It's not time yet," she would remark whenever we offered to buy her a book of poetry. Even when we did buy her a few books, they only collected dust on the bookshelf.

Akiane's initial compositions were written in a combination of Lithuanian, English, and Russian. She would either scribble the poems down and fly them to me folded into paper airplanes, or urgently dictate them to me. After Akiane created a poem, she would undertake the process of translation, irritated that the translation would take her many times longer than the original writing. What she loved about poetry was that she could so quickly and effortlessly express ideas she didn't have to discuss—ideas that nobody judged. The process of translation, however, she regarded as an intrusion into her writing freedom. She found it tedious and time-consuming, and she worried that the specific meaning she sought to express would be changed as a result.

Soon Akiane was drawn to write only in English. Now that she felt free to record the ideas spontaneously without any need for translation, her interest in writing increased. Apparently many of the poems she wrote were connected; each poem seemed to explain or respond to another, as though they were all pieces in one great and complex jigsaw puzzle. Akiane herself noted that the messages were somehow coded. It was apparent that there was much more there than the eye could see or the ear could hear.

As her interest in poetry blossomed, her interest in schoolwork faded. Not a day passed without Akiane, who was now in second grade, asking us to take her out of school. "Let me study at home. Then I'd have time and energy to do art and poetry. After school I feel drained and have no inspiration to paint. And it's so noisy at school."

"You still get good grades. Aren't you one of the best students?" I searched for a good excuse for sending the children to school, but the real reason was that I hoped they would find close friends there.

"Grades don't mean anything if I'm not interested. What's the meaning of all these studies if I can't help others? When half of the world goes to sleep hungry, what am I doing reading all those books?"

But it wasn't just words Akiane was exploring. Before long she was asking for real paints, because she had become bored and frustrated with oil pastels and their inability to render fine details.

That Christmas the boys received a golden retriever puppy, and Akiane received

her first set of acrylic paints. Right away she began working on her first painting, and for the next few days we barely caught even a glimpse of her.

When I peeked into her room one weekend, the whole blue shag carpet was covered with paint. The bedspread, the walls, her socks—almost everything was smeared with paint. I closed the door, took a deep breath, and reentered, but this time my

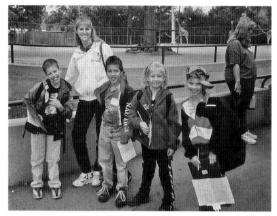

Akiane (far right), age 7, on a school field trip

eyes drifted to a Colorado winter landscape resting on her squeaky easel. Akiane was washing her brush in the amberdecorated jar that evidently was taken from my souvenir box without permission. For the longest time she assumed that if we loved one another we must share all the things we have. It was very difficult for her to distinguish her own belongings from the property of others. Since she didn't mind giving away her own possessions, it seemed fair to her that she could take something she needed from others without asking. According to her experiences in heaven, most things were shared.

These real paints seemed so different and magical to Akiane. Although she had quickly figured out how to mix and blend them, it took her a long time to figure out how to keep the paints off her body and every surface in her room. Her paint-stained clothes gave away her passion wherever she went.

After the winter holidays, Markus was unexpectedly laid off. As he struggled to find another job, we once again found ourselves seeking direction. It wasn't long before we were packing up to move again, this time to Idaho.

Artistic Marathons

Northern Idaho was one of the most idyllic places we had ever seen. Living close to a lake and to nature, and finally able to stay home and learn on her own, Akiane was inspired to paint and write every day. She was physically, emotionally, and spiritually revived. We also lived by a park, and our children often invited the neighbors over to play soccer or tennis. Soon they made new friends and spent hours frolicking and

playing. There were so many youngsters left alone while their parents worked that we sometimes stuffed our small truck with children and drove to the city beach. Our kids felt that the neighborhood friends were better off swimming with them than watching television all day long. At the beach the youngsters would wrestle, sprint, play freezetag, build sand castles and tunnels, bury one another in the sand, snorkel, jump off the docks, or just lie in the sun and relax.

Akiane loved the lake and her new friends, but more than anything, she loved spending time alone and thinking about how she could help the whole world. This was also the time she became even more interested in writing.

Very early one morning, we found eight-year-old Akiane gazing through the window at the sky, her calm face glowing. When we asked what she was doing, she answered simply, "I was taken again, and I was told to pray continually. I was climbing transparent stairs; underneath I saw gushing waterfalls. What impressed me the most were gigantic hands of pure light—they were full of maps and events. Then I was told to memorize thousands upon thousands of wisdom words on a scroll that didn't look like paper, but more like intense light. And in a few seconds I somehow got filled up. I saw the endless universe, its past and its future, and I was told that from now on I needed to get up very early and get ready for my mission. I hope one day I'll be able to paint what I've been shown."

"What mission?" I couldn't help asking.

"You cannot understand that mission now, Mom. When that time comes, you will see."

She talked like this for quite some time, and as I listened, I was overwhelmed by the spiritual insights that were deeply impressing themselves on my own searching mind. The next day Akiane wrote a very long poem.

Conversation with God

I receive an envelope with the seal of Your lips
As I am waiting for You I get covered with dust
My heavy rope is full of holes and now it's in a cast
But why are Your gates always higher than us

As we used to talk to each other before The depth for notions true friendship deepens Would You tear the tears from my salty fists The leftovers of my house are just the seeds

I see Your hands without the wrinkles, bones, or veins
Just the maps, just events, just the worlds, just the time
I see the waterfalls full of songs under stairs by Your feet
The poems whisper by the millions from Your mouth in rhyme

Every sweat drop has reached the ditch for flower Every bridge has held the storm for river The battles are still won by losing But the fools still wonder how to maim the sliver

Above the time love wraps infinity
Inside the time love brings the man
Alone with pain everyone gets humbled
Out of the hurricane the rainbow reaches like a hand

Can someone turn away from Me in search of truth
One lie could empty entire eternity
How many shadows will beat against your hearts
When on the ground your tears get dirty

Spider webs on me—How long did I rest in prayer Shoes with holes—I have not started walking yet Inside the saddled journey of the night Now I can find white blossoms in the net

After that week, there wasn't a single morning in which we missed a fifteen-minute walk to the lake to talk, meditate, and write poetry. The nature and panoramic views profoundly inspired Akiane as she watched eagles trying to separate the bird flocks, or

ducklings sunning themselves on the rocks, or trains moving slowly in the distance. Most often she would sit in my lap and admit she was completely empty and had not the slightest new thought in her mind. Then, after a quiet prayer, she would sit still and wait. Maybe half an hour would pass before she squeezed my hand. "I am ready . . . I see so much . . ." And from my pocket I would take a notepad and three pens, just in case one of them would freeze up or leak. Many blizzards, rainstorms, and blistering hot hours were experienced on the pristine shore.

Although she was never inclined to discuss it, Akiane became more and more compelled to write—and I became more and more fascinated with the process. I started noting all of the subtleties involved in her dictation, from the change in intonation of her voice to the variety of her facial expressions. She was never in any hypnotic state—it was obvious that she was not channeling or sleep talking—she was awake and alert, focused and mentally involved. Most of the time her eyes stayed wide open, as if she were watching a big fireworks display or examining something under a microscope. After she finished dictating a poem, she would kiss me on the cheek and we would return home where she would make decisions about the poem's presentation. For example, she might say, "I think this should have five lines in each verse and no capital letters, except for 'God."

Another peculiar facet of Akiane's creativity was the matching of her paintings and poetry. Although most poems were not accompanied by paintings, almost every painting was now accompanied by a poem. But how Akiane arrived at her matches mystified everyone. These poems would relate to precise visual or emotional elements of her paintings, but during the writing process she rarely focused on any deliberate parallels. It was as though the conscious matching of poem and painting occurred after both had been completed.

As we watched our daughter grow, we noticed that if she did not paint or write something each day, she felt unfulfilled. These forms of creativity had become a vital outlet for her. While it was somewhat easier to comprehend Akiane's art, which she created for weeks and months at a time, we were never able to understand the source, the method, or the pattern of her writings. As soon as we were convinced that they arrived in a certain way, something would happen to show us that we didn't have the whole picture. Her prophetic drama zigzagged through what she called "the maze

inside the puzzle." Yet as we watched her daily, she appeared to be a typical girl her age and rarely gave the impression of being a serious thinker.

Often Markus and I were both intrigued and disheartened by our daughter's complete indifference to public opinion. One day I noticed that Akiane had referenced the fact that glass was made from sand in her poem "Chipped View." When I asked her how she knew this, she was surprised herself. "I didn't know. Whatever popped into my head, I wrote down. You know that these thoughts just come to me."

"Well, how will you explain what you write to others?" I could just imagine how difficult it would be for others to believe that these poems were actually her work.

"Don't worry. Why do you concern yourself with what other people think? You see, Mama, when you love, you can't describe it either."

Chipped View

If some are chosen to bow down to wear the yokes Some are chosen to live in a spark The scabs are puzzled everlastingly Weaned honor is delivered in the midst of dark

Bowing to themselves the crownless kings
Sit in their own bent thrones
As cattle live in castles full of lion clawprints
Life becomes the play with ashes of the drones

Before the glass palaces—the sand
Before ruby swords—the fists
Before the chipped heaven—the chipped view
The nestlings in the marble nests.

Along with her increasing love for writing poetry, Akiane went back to her painting with such drive and stamina that Markus and I had to insist she take breaks from her

artistic marathons. "One more shadow—wait, one more minute," she would say, totally engrossed in her own world of forms, colors, and stories. Most often she didn't allow anyone to watch her paint. If we forgot to knock at her door and entered before she had time to turn the easel around, she would be extremely upset. "Out!" she would shout. "Now you've spoiled my surprise. I can't work like this. Everyone is coming and going like weasels by the easels. Leave me alone! Everyone! Please! This is not the post office!"

Disinterested in anyone else's comments or criticism, Akiane worked with confidence far beyond her years. She quickly progressed to larger and larger canvases, painting allegorical scenes, images of nature, and portraits. Meanwhile, she experimented with different media and styles—from expressionistic color sketches to realistic oil paintings.

But despite her dedication, she continued to bewilder us with her complete indifference to the work of other artists. She declined all offers to visit museums or galleries, as well as the chance to study at an art school. Perplexed, we nevertheless arranged for her to take a class from a local artist, but Akiane returned from her first session quivering with indignation. "It was the dumbest lesson in my life. The teacher held on to my hand the whole time. That isn't teaching—that's cheating! I don't need teachers. I need students." She looked again at the watercolor landscape she had done in the class and tore it in two.

The same week over a dozen neighborhood children came for her art classes.

The Prince of Peace

One of the most uncanny events surrounding Akiane's art was her discovery of one particular model. Desperately wanting to paint portraits of Jesus, and inspired by her own visions and impressions from her former school chapel, she spent a lot of time searching for the right face. For over a year she had been looking for the perfect representation of Jesus; she stood by supermarkets, shopping malls, parks, and on city streets, watching thousands of faces pass by, only to shake her head.

One morning she asked us to pray with her throughout the day about her Jesus model. "I can't do this anymore. This is it. I can't find anyone by myself," eight-and-

a-half-year-old Akiane tearfully disclosed. "I need the right model and the right idea. Maybe it's too much to ask, but could someone send him right through our front door? Yes, right through our front door."

The very next day, in the middle of the afternoon, the doorbell rang and an acquaintance brought her friend, a carpenter, right through our front door. She introduced him to Akiane, thinking that the young artist would like his features.

"Tai jis! This is he!" Akiane blushed, observing the carpenter standing almost seven feet tall.

"Kas jis? Who is he?" I asked her quietly in Lithuanian.

"Tai vyras kuris modeliuos Jezaus paveikslui. Labai panasus i mano pasikartojancias vizijas. This is the man who'll model for the Jesus painting. He resembles the image that keeps coming back to me in my visions."

We were stunned at the prompt response to our intentions. In our excitement, we all touched the man to make sure he was real and that we were not dreaming. He was in jeans, a white T-shirt, and a pair of old sneakers. His voice was deep and peaceful, and though he said only a few words, we learned that his life was quite extraordinary. Yet what struck us most was his demeanor—a balance of meekness and poise.

After he left, Akiane couldn't find words to describe her thankfulness. She stayed in her bedroom for hours, sketching all possible angles for her future portrait. But a week later the carpenter called her to apologize, stating that he felt unworthy to represent his Master, and that he had to decline the honor. We were all disappointed, but Akiane refused to give up, praying even more feverishly that day, the next day, and the next.

Another week passed before the carpenter called us back. "God wants me to do it, but I have only three days before I have to cut my hair and beard."

Akiane couldn't have been happier. Soon afterward, she choreographed the poses, studied the carpenter's face, and took several pictures. She was anxious to begin her sketching and right away decided to start with the resurrection scene for the *Prince of Peace* painting.

We were amazed by the quick pace at which she was working. She was so pleased about her progress that she even allowed us to videotape her. It took her only forty hours to finish the portrait, but in that short period of time she lost a total of four baby teeth—a tooth for each ten hours of painting. At one point, desperately needing a thin brush to paint eyelashes, she even cut a strand of her own hair and made a fine brush.

Watching the portrait develop was almost like watching a microscopic embryo develop into a newborn. Physically, artistically, and logically, the process of her painting was incomprehensible, as though pure power was vibrating through her every vein.

While the painting was drying on the white wall of the studio, every viewer was quick to notice that no matter where you stood, Jesus's eyes followed you. Although the portrait resembled the model, Akiane had altered his expression and features to mimic the resurrected Jesus she remembered from her dream. Many times we overheard Akiane share the meaning to others. "The light side of His face represents heaven. And the dark side represents suffering on earth. His light eye in the dark shows that He's with us in all our troubles, and He is the Light when we need Him."

Upon completion of this painting, Akiane immediately began sketching the profile for her next portrait of Jesus. The position of the hands in the composition turned out to be an enormous challenge for her. Our bedroom was adjacent to Akiane's studio, so very early in the morning we would hear *bam*, *bam*, *bam* into the wall. We knew this sound well; she was blending on the canvas. But no matter how difficult an area of the painting was for her, she never gave up and kept repeating, "I want this portrait to look real. Real, real, real, real!"

At one point, while she struggled to represent the hands, Akiane decided to add more red but had run out of paint and walnut oil. I quickly ran to the store to get the correct shade she'd requested, but when I returned home, I discovered I'd bought the wrong hue. A frustrated Akiane sent me back to the store, but what I brought home was once again the wrong color. What made it so difficult was that Akiane didn't even know the names of most of her paints. To give me a guide for my next trip to the art store, she went to the kitchen, took a steak knife, nipped her thumb a bit, and squeezed out a droplet of blood onto my hand. "This is the exact color I need—and hurry, before the color changes!"

When the body was almost finished, she spent the whole week experimenting with the background. After adding, removing, and again adding a beam of light from His eyes, she decided to remove it. "We can't see that. It's only Jesus who sees that light. Let people imagine what's behind the black." So she mixed some blue with black and, from her ladder, painted over the beam for the last time.

Our family still couldn't afford a professional easel, so Akiane was working on the easel her dad had built from scrap wood. It was very difficult for us to hold ourselves

back from complaining about the mess that was spreading throughout the whole ranch. The chairs, tables, bedcovers, dishes, towels, and doorknobs all tracked Akiane's whereabouts with smears of oil paint. But we all knew how exhausted she was after painting,

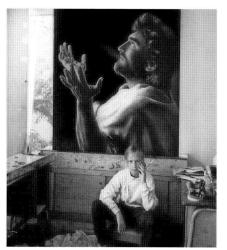

Akiane working on her second painting of Jesus, titled Father Forgive Them

so her brothers graciously began taking turns washing the oily brushes and glass palettes.

Many people began coming to see Akiane. All of them said the same thing: "We can watch this process, but we still don't believe it. It's impossible. We wonder how others, who *haven't* seen how she works, could ever believe it."

We shipped the *Prince of Peace* to an art agent who had agreed to represent Akiane's work and who had promised to find a buyer for the painting. But when he found out that Akiane had begun painting yet another Jesus portrait, he became angry. We felt strongly that we needed to find another agent. When we asked him to release us, he refused. "I will not terminate the contract," he roared. "According to the agreement, she'll have to wait nine more years . . . unless you want to buy me out

for \$100,000?" Then he threatened to keep *The Prince of Peace* as long as he cared to, asserting his authority as the manager. Unexpectedly, Jesus had become a hostage.

After praying for the safe return of the painting, a chain reaction of the most unusual events led to the arrival of the semi-dried oil of Jesus on our front doorstep—exactly on the day of Akiane's birthday. The painting was delivered in a bent crate full of sawdust, so a tearful but relieved Akiane had to work hours with a vacuum cleaner and dry brush to clean it up. "My goodness! He looks just like after the Crucifixion . . . full of sawdust." Akiane squinted. Miraculously she was able to lift all of the embedded sawdust from the surface, and later that day she was able to celebrate her ninth birthday, not with candles, but with two Jesus paintings.

Many months later, thousands of people were discussing the two portraits of Jesus. Among them were scientists from Russia who noted that Akiane's *Prince of Peace* had a remarkable resemblance to the mysterious image taken from the very Shroud of Turin. Puzzled scholars from India were fascinated by Akiane's depiction of a towel robe, for, according to them—and unknown to Akiane—adult Jews wore similar robes during worship two thousand years ago. In addition, hundreds of people from all over the world wrote to Akiane saying they were shown this exact portrait during their dreams.

The Stage

Soon we looked for a miracle to find a way to break away from the art agent. We had no resources, for Markus had recently been injured at his job and was at home with us. Another child prodigy "expert" suddenly appeared in our lives, but he was mostly interested in the expressionistic paintings that Akiane sometimes created at one sitting between her more time-consuming works. Since Akiane did not want anyone to see these rapid color sketches, which she often called "immature," she preferred to hide them in her closet or under her desk. Nevertheless, before long the new agent agreed to represent Akiane and offered to help obtain an expensive legal separation from the previous manager. Rationalizing and pushing aside the red flags, we decided to try out the new agent.

At this same time, an unexpected thing happened. Our family had sent news about Akiane to the media, and in response, nine-year-old Akiane was invited to appear on *The Oprah Winfrey Show* in a segment called "The Most Talented Kids in the World."

On the day of the shoot, Akiane stepped out of a black limousine onto the Chicago streets and into the studio, with her huge paintings arriving separately in seven-foot crates. The media staff placed a wireless microphone transmitter under Akiane's navy blue dress, and the makeup artist combed her straight hair, smearing some Vaseline on Akiane's lips. In the Green Room one of the youngest and most famous fashion designers in the world kissed Akiane's hands. "Oh, my goodness! So these are the hands that created the most astonishing paintings in history! You are a true genius!"

I pulled Akiane aside. "Remember," I whispered, "your new agent told us that you shouldn't focus on God so that you don't offend the viewers of different beliefs. Remember when I used to be very offended myself by just hearing the word *God*? Do you know who Oprah is?"

"No, yes, no!" Akiane was in a whirlwind.

"You'll like her." I stopped there; I didn't want Akiane to realize right then and there that this was one of the most popular and beloved television shows in the world—a show on which many professionals dream of appearing. I didn't want to start explaining how legendary this woman was until the lights and cameras were off.

Before we knew it, Akiane was climbing onto the stage. At the end of the interview, Oprah asked, "Where does your inspiration come from?"

"From God." Akiane couldn't keep from mentioning the most important influence in her life.

"From God . . . ," Oprah repeated and hugged her.

We flew home from Chicago enlivened but exhausted, only to find that the ABC television crew would be coming over in a few days to videotape Akiane. Shortly after this, CNN's crew came and filmed Akiane for an entire day in preparation for the feature story of the *Lou Dobbs Show*. When Akiane was painting *The Journey*, the producers were immensely interested in watching her painting process. After hours and hours of videotaping her painting and talking, the producers admitted that they'd never seen a child who could endure such a long day of interviews.

Following this, Akiane was invited to many other shows. After one of them, on the plane back home, she saw the city from above and asked, "Mom, where do people go to rest? It's all concrete for miles. Where's the pen? Could you write down a few sentences for me?"

Akiane put her head on my lap and closed her eyes. She had developed a high fever, but she just had to get the poem out. My head was spinning as well, but I pulled out a blunt pencil from my pocket. Akiane dictated in Lithuanian, because she didn't want others around us to understand what she was saying. Within a few minutes, *The Stage* was effortlessly dictated to me. Then she stopped and looked at me with her red and runny eyes. "*Am I too young to be found?* Put that down. That's the end!" And Akiane fell fast asleep.

The Stage

The howling eyes forecast the plainest heart And I forget my chivalry monsoon. Crippled meaning of my brittle bravery Shrinks cowardly with every balding noon. I creep under lost victory

To hear bitter beats of drumming theft.

Throughout my courage traffic changes lanes

If I forget which role I left.

The mass of the self never ends . . .

Shall I put on the mask to complete the face?

All of a sudden on a stage of words

The meaning becomes just a dress in lace . . .

Lusterless gazes beat like weakened wings Against the pillow curtains of a pulpit dump. The rhythm of the chaos lacerates aroma Till it becomes a fragrance stump . . .

The fresh cut could still be smelled—
But the profile of the sound hides like a fraud.
In front of lenses—the close-up of the rouge
The flatter still pretending to applaud

The drama map reveals how long I will spin
On a blank canvas of the stage like dice.
As I drill the brush into the sketch, I drizzle
And my dew veil covers the coconut eyes . . .

I bolt my fingers into the lame horizon of the audience Where ovation changes like an illusionist's hand I mime around until I smell the tangled hair All pulled into the theater fan.

Am I landing on a stepping pedestal of mystery
Where truth with frosted hair dives blue face down?
The wrinkles show up with each flicker of the candle—
If I left them for God—am I too young to be found?

Jesus's Missing Years

Within a few short months the second art manager stopped representing our daughter, and we were on our own again. As Markus worked full-time at the hospital and I homeschooled, we continued to help Akiane with her art shows. Before her tenth birthday Akiane embarked on another painting of Jesus—this time showing Him as a very young man during His missing years. A few weeks after she had started the painting, something about it began to upset her. The near-finished portrait was losing its charm, and Akiane was ready to gesso over the whole canvas and start over. "I'm feeling His anguish." The entire month was filled with artistic frustration, but at the end of it Akiane worked out the problem areas and began aggressively repairing the whole face and figure, brushstroke by brushstroke.

As I was sweeping one afternoon, I overheard Akiane talking with her three-yearold brother, Ilia. "Why am I laboring over this painting? I'll just paint two ears and call it *The Missing Ears*. It'll be so easy."

"Isn't today your day off?" I asked.

"Yes, today I play."

"Are you playing right now?"

"I am. Today I'll play on the canvas." She wiped the excess paint from her brush, not on a paper towel, but right on the canvas itself, leaving streaks of different colors by the figure. Then she quickly ran outside and brought a few children into her studio to ask their opinion about Jesus's age, and everyone agreed that He looked many years older if you stood at a distance from the painting. But Akiane corrected them. "He is timeless—and because of that, you can catch a glimpse of Him as a teenager and an adult all at once."

With one big mirror at the end of her studio and a smaller one in her right hand, she was meticulously checking the slightest inaccuracies. "I have to blend the sides of the lower lips with the skin a little more," she explained, scratching her paint-splattered forehead, "and then it should look more natural."

"I've noticed that you are getting more patient. By the time you finish this work, it could reach . . ."

"Two-hundred hours! That's what, three months now?" Akiane completed the sentence. "You know, I decided not to rush. The turtle wins the race, right?"

"Usually, yes, if its shell isn't too heavy."

"This isn't abstract art. This is realism: it takes time."

Later that day when I was kissing Akiane good night, I began asking her about one planet on her canvas.

"Oh, that's the new earth. I just felt that I had to include it. I don't remember where, when, or how, but the earth will change. All I know is that everything will be different. There will be no fear, no hatred, and no hunger or pain. Only love."

"Why is it all green? I see no blue oceans."

"I don't know. Maybe only rivers and lakes will be there. Why do you ask me as if I know? I paint what I can remember from my visions."

"Is your Jesus looking at the galaxies?"

Akiane closed her eyes. "No, that's behind Him."

"Then what is He looking at?"

"I'll tell you tomorrow."

I gently pulled open one eyelid to get her attention. "What is He looking at?"

"Mom, you have no imagination . . ."

"You aren't asleep yet. Go ahead, tell me."

"I'm sleeping."

"No, you're not."

"Tomorrow!"

"Please!"

"You have no patience, Mama. He is talking with God. Right here you can see the whole birth process of our new universe."

"Why is the new earth behind some clouds?"

"It's hidden for now." She pulled her blanket off her bed and, with a down pillow held between her teeth, tiptoed to our bedroom to lie down.

Why Akiane?

Although Akiane was sure about her unique abilities, there were many days when she questioned her mission. One morning as we were wiping up a spill by her easel, Akiane wondered aloud, "Why was I chosen instead of some other child?"

"Akiane, I have no clue. The more I know, the less I understand. You hated traveling; now you travel. You were shy, and now you're on the stage surrounded by people and cameras. You were stubborn about chores, and now you paint for months to create detailed pictures. Your weakness was language, and now you not only create poetry but spend hours talking to people about deeply profound issues. You had a hard time remembering, and now you've learned sign language on your own. You were strongwilled, and now you are attuned to profound spiritual insights."

"I still feel like I'm the wrong person. Someone else would be much better." As we scrubbed the floor, she spoke in English. Lately she preferred using her dad's native tongue.

"Maybe it's what's inside our hearts." I kissed her.

The next day was very cold and rainy. My sons came to meditate with me by the harvested and plowed farm field approximately a half-mile away from our house. It was usual for us to spend every morning with nature no matter what the weather was like. This day Akiane didn't show up. An hour later, totally drenched with rain, I came home and saw my daughter signing on the left bottom corner of the canvas. Usually that meant she was going to finish the painting within a few days. I tried to ignore the mess surrounding her, but then I heard *splash!* Right before my eyes she dropped a paper-plate palette full of paint on the floor, and now it was lying upside down. I picked up two dried-up filbert paintbrushes and an unscrewed paint tube by the recliner and looked at her impatiently.

"Please, leave me by myself!" she said, raising her high-pitched voice. Similar reactions were usual, but I had learned long ago that arguing with her at such times was pointless. No reprimands, corrections, or consequences had ever affected her. She had absolutely no fear. She paid serious attention only to gentleness. A simple hug with a kiss was always more powerful than any admonition, chore, or loss of favorite activities. Sometimes it looked to us as if God, not we, was her main authority. She always lived in a world quite different from the one we provided for her.

We had never seen a child so stubborn yet so lighthearted, so strong-willed yet so loving, so witty yet so childish, so independent yet so social, so introverted and yet so friendly. "Why her?" we often wondered, bewildered by her complex character.

Later that night, as I was kissing Akiane good night, I mentioned to her that the Crystal Cathedral had invited her to visit.

"How many people will see me?"

"About four thousand in the audience and about ten million on TV."

"Sometimes I just wish I could be a normal kid, and no one would see me and no one would talk about me. Yet I feel I need to do it."

I hugged her and told her that many inspired Muslims, Buddhists, and atheists had written thank-you letters to her. But Akiane was not surprised—she explained to me that it had to be this way. As she curled up into a ball, I kissed her on her forehead. I was suddenly taken by the feeling that I didn't want her to grow up.

"I will sleep with you and Ilia tonight." she said.

She lay down and fell asleep almost instantly. The rock necklace she'd recently polished for herself was still strung around her neck. Her hair was uncombed, and her blouse was splattered with fresh paint. As she lay on her back, she breathed quietly next to her snoring baby brother. I felt I could understand her better when she slept. Then I was able to hold her hand and talk to her, and she couldn't hear me.

"I Belong to God"

By now Akiane was ten years old, and word about her had begun to spread to museums. Before long she was invited to the Museum of Religious Art in Iowa, and the three-day exhibition proved to be an unforgettable event.

The minute we reached the museum, we saw a full parking lot and masses of people standing in a line that wound from the outside doors down the road—and the line was getting longer with every passing minute. Thousands of people stood for many hours just to get Akiane's autograph. Visitors had arrived from various states, and some had flown in from the West and East Coasts. There were doctors and artists, mayors and professors, art collectors and lawyers, journalists and executives, students and toddlers. There were handicapped people in wheelchairs; there were elderly folks with their walkers—even a 102-year-old grandmother. Several teenagers attended the exhibition, drawing in their sketchbooks as they observed her images displayed on the high walls.

Men and women alike were deeply moved as they passed by our daughter and her huge paintings. Everybody wanted to ask her questions. One crippled lady stood

up from her wheelchair for the first time in many years just to have her picture taken next to Akiane. There were also numerous people who asked the young artist to bless or heal their families and to pray for their problems and illnesses. The museum staff paced around astonished at the number of people who had shown up at the event.

The questions poured in to Akiane from all directions. "What church do you belong to? What denomination?" someone from the crowd asked loudly.

"I belong to God," Akiane responded.

"Do you relate better to adults or to your peers?"

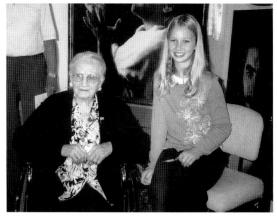

Akiane and a 102-year-old grandmother at the Museum of Religious Art exhibition

"To adults and to babies."

"I am a Buddhist. You called Jesus the "Prince of Peace," yet in His name so many people were massacred. How do you explain that?"

"Jesus is peace, just like calm water. But anyone can drop a stone into water and make it muddy."

"Why did you choose Christianity instead of another religion?"

"I didn't choose Christianity; I chose Jesus. I am painting and writing what I am shown and what inspires me. I am a journalist artist. I don't know much about the religions, but I know this: Love is our purpose."

"Have you seen UFOs, since I see you've painted a few right here?"

"I don't know what they are, and I don't remember if I've painted them. If I did, that means there is a reason, but people have to solve that reason by themselves. Each inch I paint on my canvas—whether it's about pain, joy, or mystery—is meaningful."

"How would you describe your style of painting?" came another question.

"Akianism—a blend of realism and imagination."

"What do you like painting most?"

"Faces. They are more meaningful to me than anything else. A face is the first thing you see when you are born. We cannot live fully without seeing or touching a human face."

"What message do you want people to get from your art and poetry?"

"I want my art to draw people's attention to love, and I want my poetry to keep their attention on love." Amazingly, the constant attention, handshaking, and autographing did not wear Akiane down. After three days of commotion, which included an auction, a television show appearance, and interviews for *Time* magazine and other publications, we flew home in a daze. Back at home we went through the many gifts Akiane had received throughout the trip. One gift bag in particular moved us; it contained a photo of a ten-year-old boy who had brought his family to the museum. He was curious to see a girl his age who could paint better than he could—he was so captivated that he even insisted on coming the second day as well. We could remember him admiring Akiane's paintings and speaking to her on several occasions. Then moments after he left the museum, due to a previously undetected malignant brain stem tumor, he had a stroke and was immediately rushed to the hospital. During this time, the boy was greatly comforted by the memories from the museum exhibition and Akiane's love for art. Before he died, the final thing he wanted to do was to draw.

Doors to Faith: A Message from the Publisher

With the increasing international media exposure and many solo art shows across the country, the Kramarik family's life has become more and more public. Ten-year-old Akiane's works have been displayed in galleries, museums, auctions, and private collections around the world, with prices for her art reaching into six figures. She was inducted into The Kids Hall of Fame, has published her first book, the one you now hold in your hands, and is regarded as the youngest binary prodigy in both realistic art and poetry in recorded history.

Akiane's parents, in gratitude watch as Akiane continues to develop and mature. Before the public recognition, Akiane's life was quite simple. Now, with various documentaries and the media coverage—interviews, appearances, traveling, autograph signing, and charity events, all that has changed. There are prints to proof and sign; paintings to create; art exhibitions, schools, and universities to attend; and thousands of e-mails and letters to answer from fans, academies, hospitals, prisons, churches, government agencies, and entertainment studios. Yet Akiane herself somehow seems to remain completely unaffected by all the public attention and recognition. She sees it all as just "another skip over the rope."

For some reason, ordinary people have been able to understand Akiane's deep and complex poetry. The message of faith is recognized by people of all religious and philosophical viewpoints, and the art is absorbed easily by both young and old. Akiane believes that if she has been blessed, there is one reason and one reason only: to help others.

Although most of her work is serious, people meeting Akiane find her totally carefree, humble, vivacious, and lighthearted. They don't see a philosopher or an eccentric artist, but rather a playful young girl who enjoys many different things, such as playing chess, composing on the piano, weaving, cooking, or just dreaming. It seems that all along, God's protection of Akiane's childhood innocence has been through her selective memory—something that had so worried them for many years. For how else could a child show awareness of such intense adult emotions and spiritual events without any negative consequences afterward? It's another mystery, yet anyone who knows Akiane observes how easygoing and unself-conscious she is, how she loves people, and how

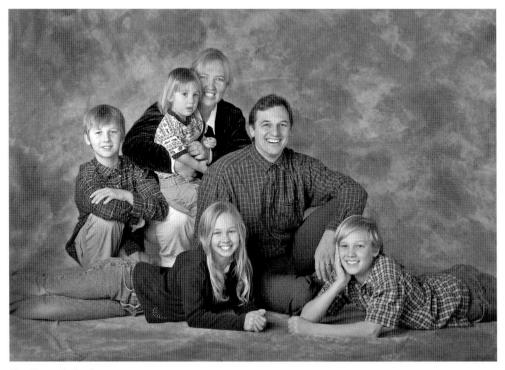

The Kramarik family

young children knock on her door every day just to play with her or watch her entertain them, covered from head to toe with paint, like a living canvas.

For the first eight years Akiane's family was frustrated with the peculiar circumstances that led to their daughter's lack of exposure to other children her age, but now they see providential wisdom in closing those doors. How else would they have been convinced that her artistic transformation came directly from her spiritual connection and not from their own neighborhood or society?

Akiane continues to believe that without dreams there is no hope and there is no tomorrow, that dreams are the doors to faith. She believes everyone has some talent they can cultivate and use to serve others and that the greatest gift we have is love.

akiane her art

The Hollow Compasses • AGE 6 (oil pastel on paper; 14" x 20")

The Empathy • AGE 6 (oil pastel on paper; 12" x 18")

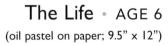

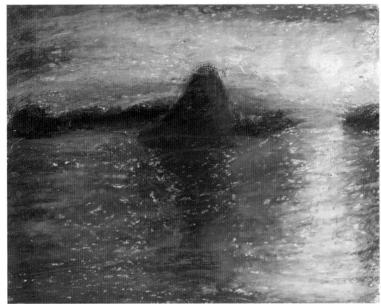

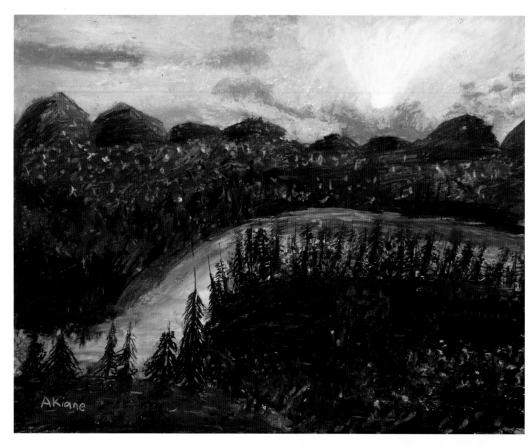

The Rainbow River AGE 6 (oil pastel on paper; 30" x 36")

The Growth (self-portrait)

AGE 6

(oil pastel on paper; $30" \times 36"$)

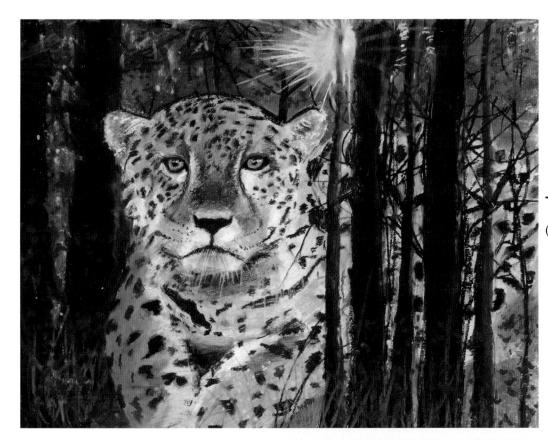

The Waiting • AGE 6 (oil pastel on paper; 30" x 36")

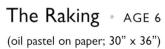

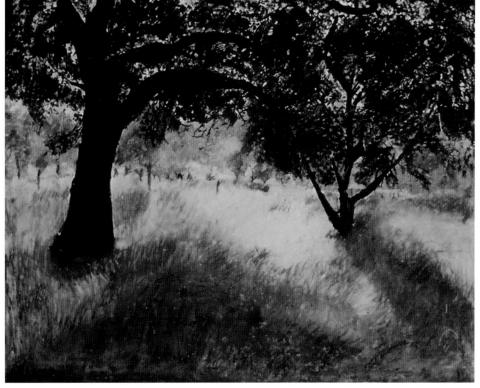

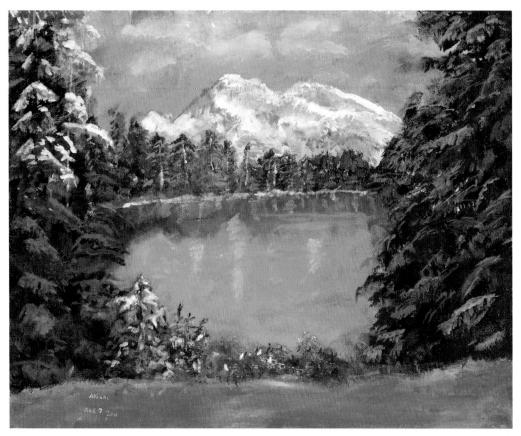

Again I Find the Winter • AGE 7

(acrylic on canvas; 18" x 24")

When I was seven, we had one accident and illness after another in our family—and once we even got lost in the Colorado Mountains. I was so car sick from all the switchbacks, but then I saw a lake through the trees. When we finally found our way back home, I knew what my first acrylic painting would be.

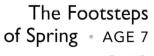

(acrylic on canvas; 20" x 30")

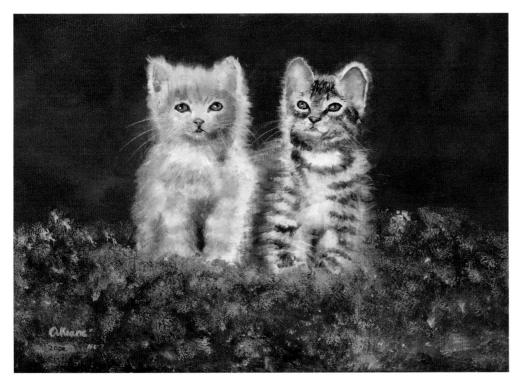

The Dreamfence • AGE 7 (acrylic on canvas; 26" x 36")

When I was seven, a neighbor gave us a strawberry-red kitten. We called him Charlie. But after a month, due to my father's and my baby brother's severe allergies, we had to find another home for our kitty.

The Horse • AGE 7 (acrylic on board; 22" x 34")

One day on a farm, I saw one horse. I don't know why it appeared funny to me at that time.

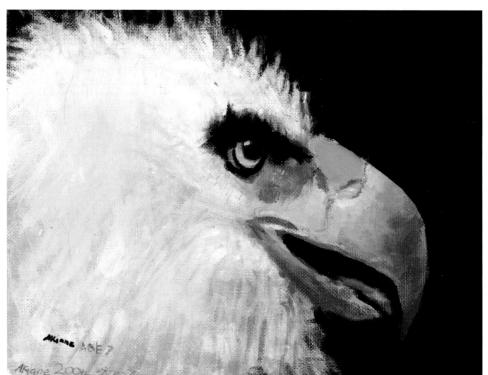

The Eagle • AGE 7 (acrylic on board; 9" x 12")

Each • AGE 7 (acrylic on canvas; 18" x 24")

My father was injured and without a job, my baby brother was very sick, my mom was homeschooling us four children, and we were very poor. I was seven and stubborn. I wanted to paint, but we had no money for paints or canvases. I found in the garage a small canvas and two semi-empty pails of paint—one white, the other burnt umber. I painted this landscape to show how each day is important, whether we are rich or poor, sad or happy, because we grow from all our experiences. Right after finishing this painting, I decided to teach small children art to raise money for my art supplies.

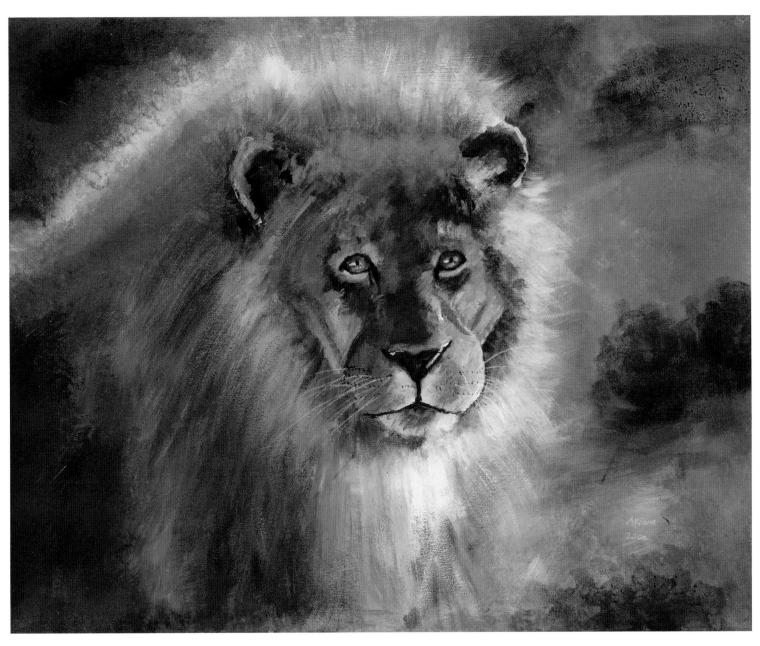

Strength • AGE 7 (acrylic on canvas; 30" x 40")

Color Sketches, and Expressionistic paintings

The paintings on this page are studies of various subjects created in one sitting.

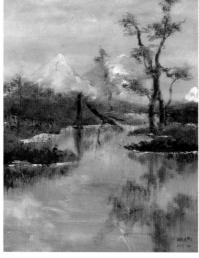

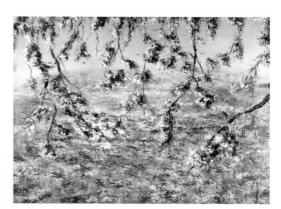

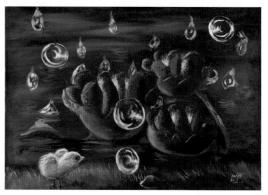

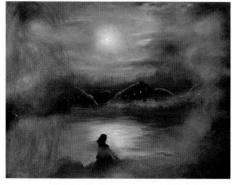

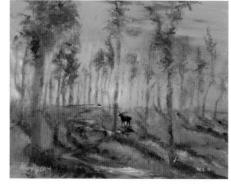

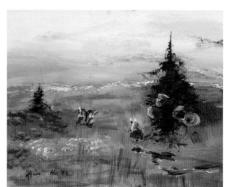

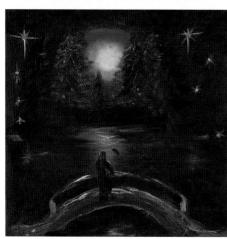

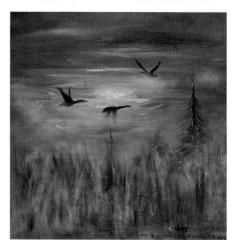

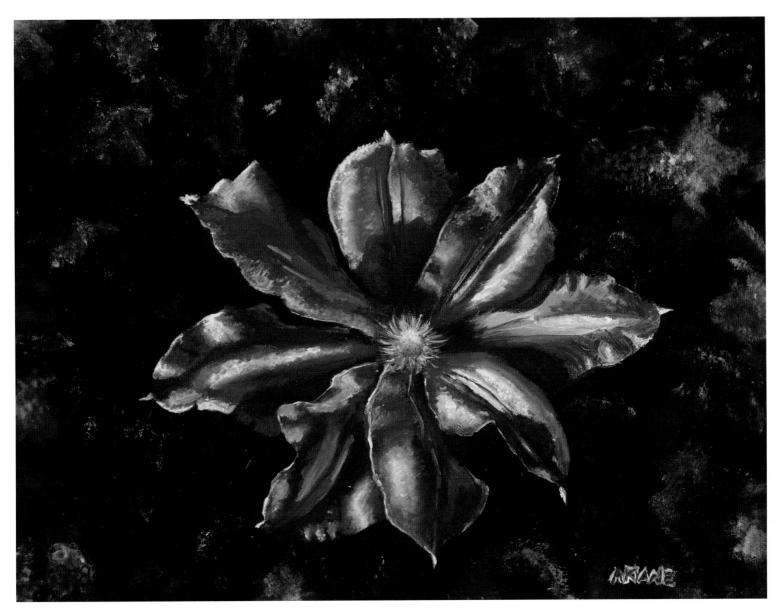

The Clematis Dream • AGE 8 (Oil on canvas; 36" x 48")

In the Japanese garden in our backyard, I noticed one clematis flower that seemed to be floating in the air. The next morning I woke up from a strange dream, wrote it down with a chalk on the window, and began painting the blossom.

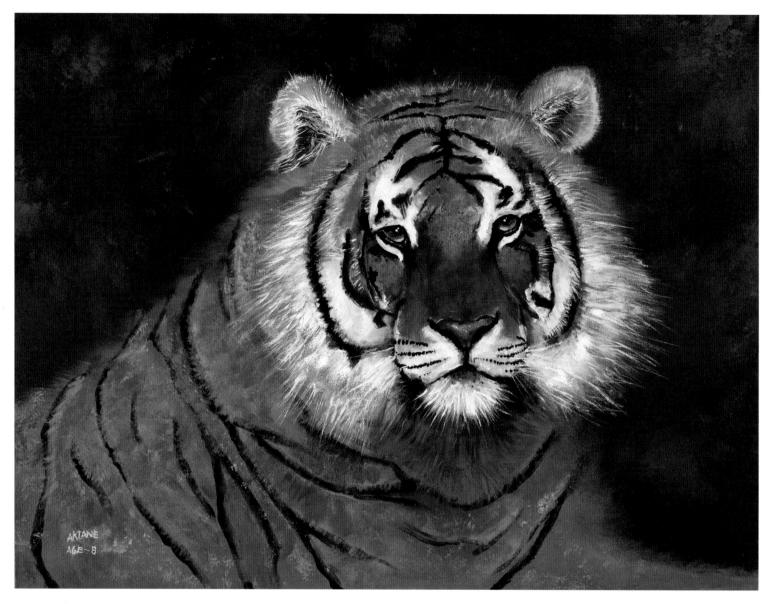

Listening • AGE 8 (acrylic on canvas; 36" x 48")

The orange is the color of listening, I was hoping to create an allegory about listening with this attentive tiger—a portrait representing the noble leaders who listen to the needs of their "jungle."

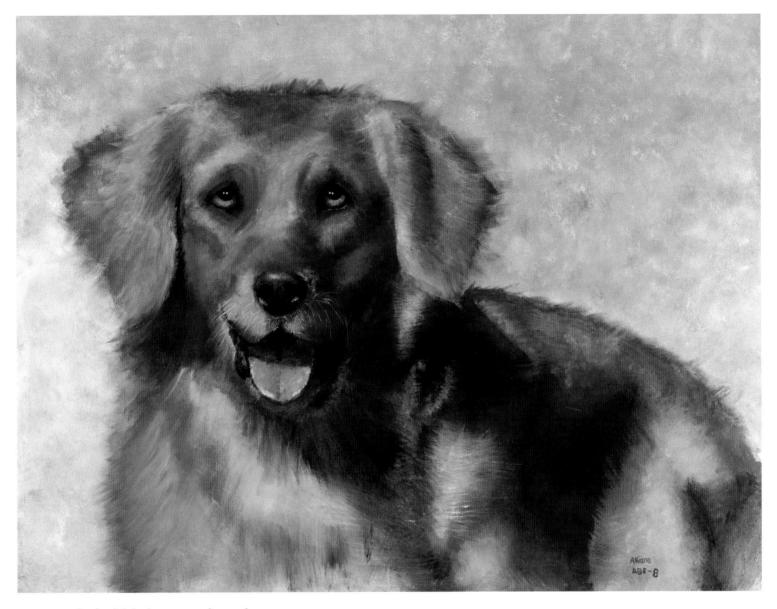

Life Without a Leash • AGE 8 (acrylic on canvas; 36" x 48")

From the time we first got our golden retriever, Simba, he's always been so loyal and brave. And with those begging eyes, he knows very well how to get from me anything he wants. One day when I picked out the four-foot-long canvas at the art supply store, I knew I wanted to paint him twice his real size. And that's how he seemed to me every day: big-hearted. It was my first huge painting and one of the easiest to paint. When he saw himself, he licked the corner of the canvas, as if to show me where I should sign—and that's when I decided the painting was finished.

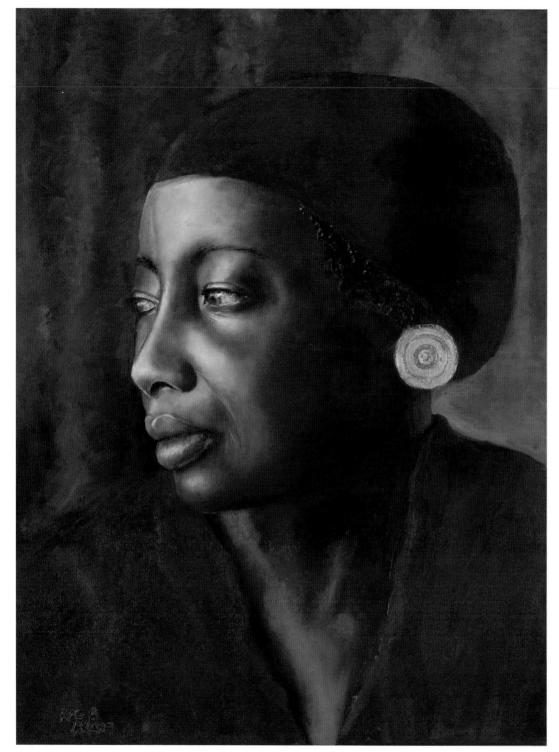

The Planted Eyes AGE 8
(Oil on canvas; 36" x 48")

In THE PLANTED EYES I wanted to express the beauty and the suffering of the black race. It was my first oil painting and the fastest portrait—taking me only fifteen hours from a sketch to the very end.

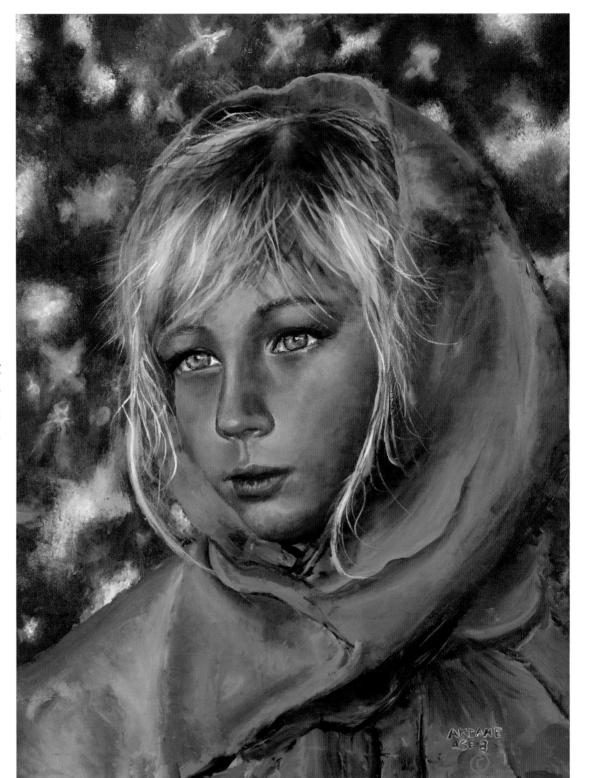

My Sight Cannot Wait for Me AGE 8

(acrylic on canvas; 36" x 48")

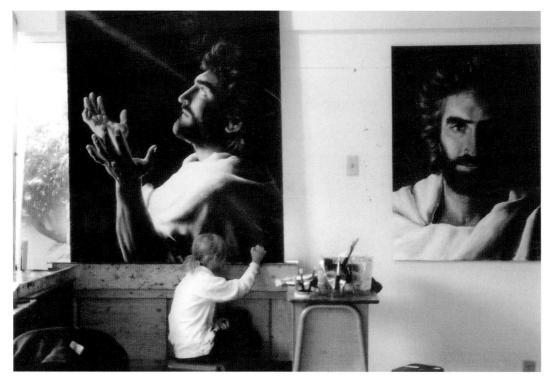

Akiane at work on Father Forgive Them.

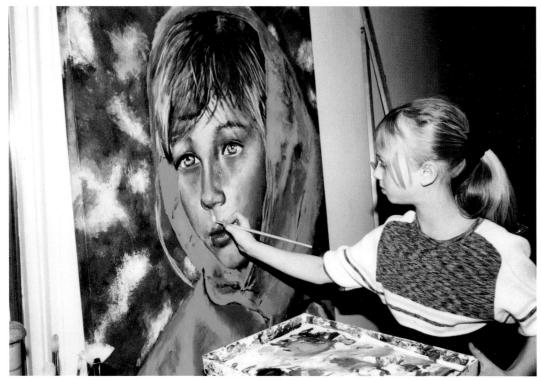

Akiane painting her self-portrait.

Progression of Prince of Peace

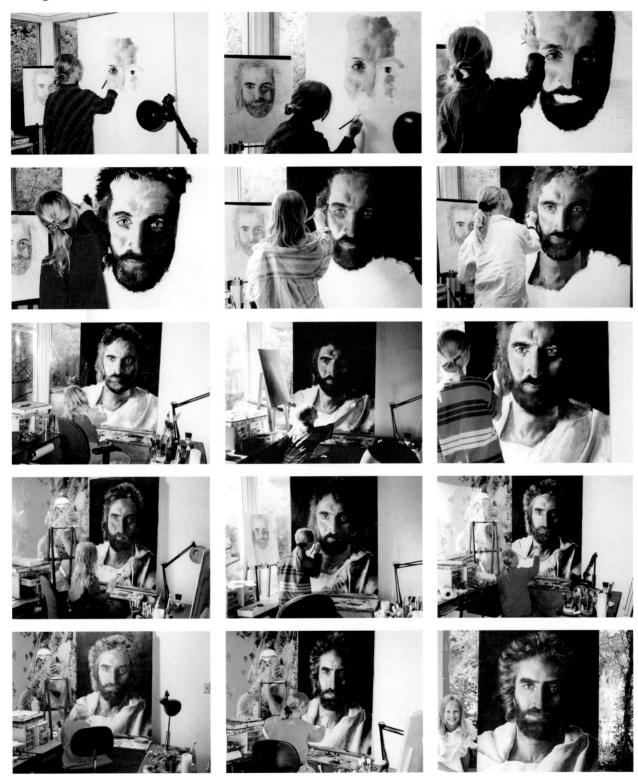

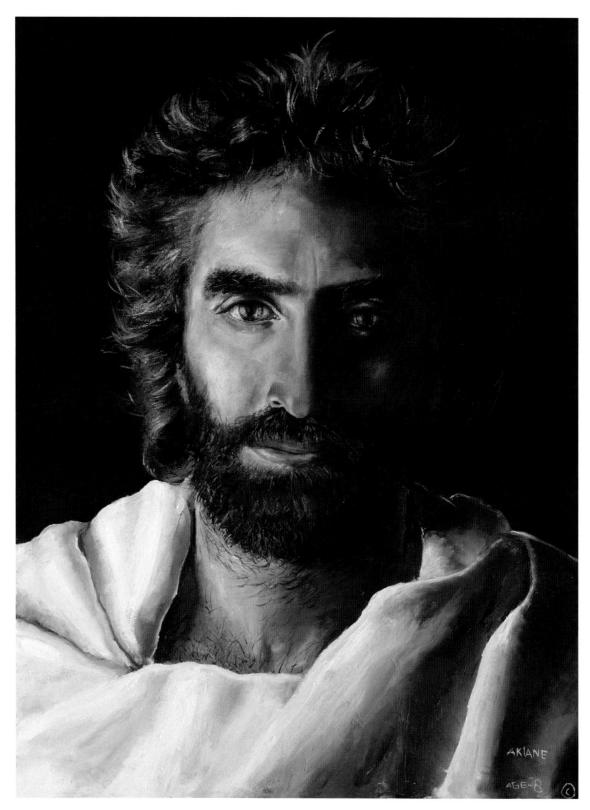

Prince of Peace: The Resurrection • AGE 8 (oil on canvas; 36" x 48")

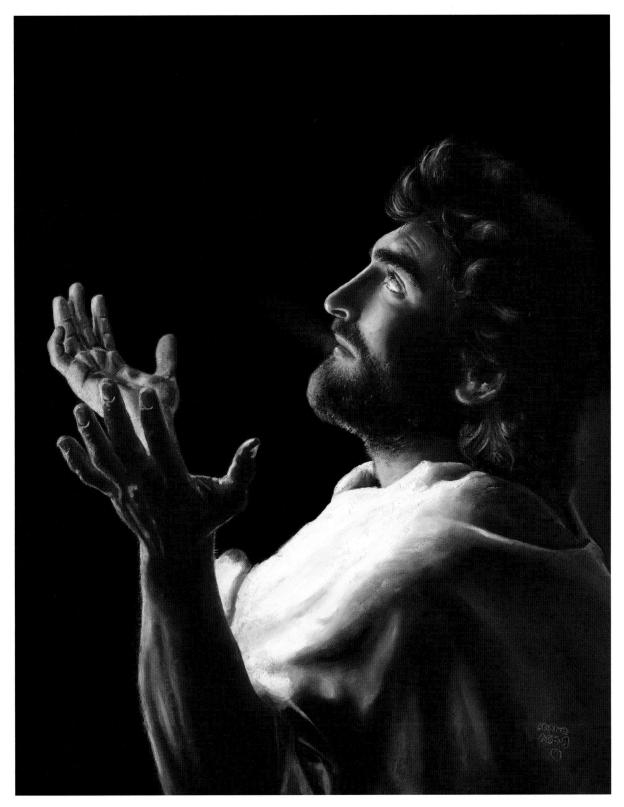

Father Forgive Them • AGE 9 (oil on canvas; 48" x 60")

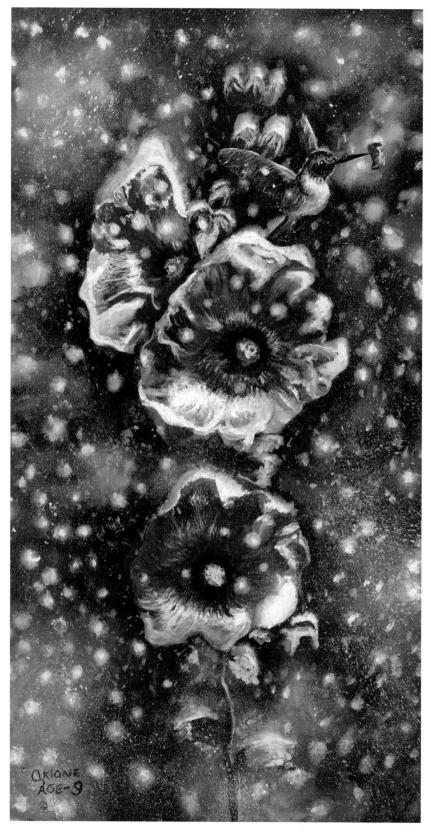

The Summer Snow AGE 9

(acrylic on canvas; 26" x 46")

The story of a hummingbird rescuing a flower from a summer snow was created in a few days after a hail like snow crushed all our flowers in the garden. As one hummingbird was still circling around the most beautiful blossom, I immediately ran to my studio and grabbed my brush to play with my paints.

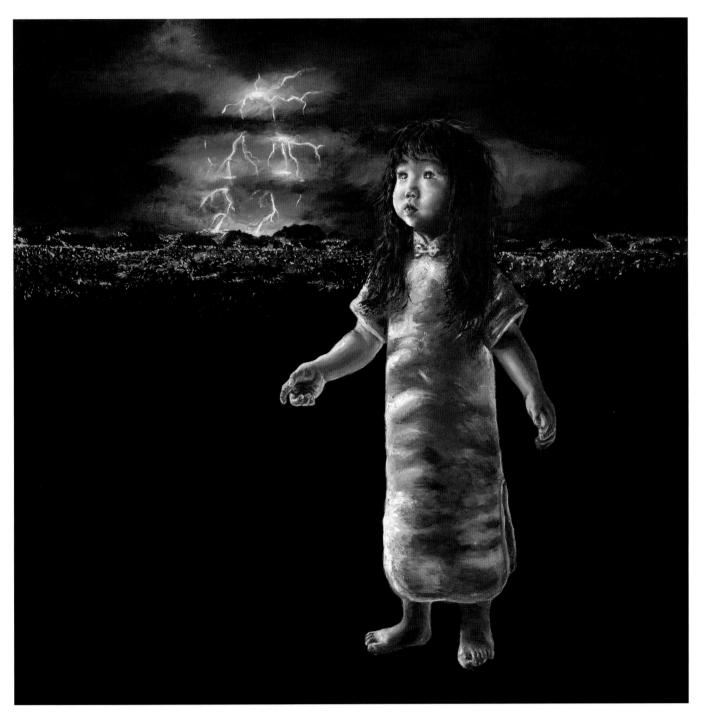

Faith • AGE 9 (oil on canvas; 54" x 54")

Without you I cannot be what I want to be and without me I cannot be what you want me to be...

Tied up to a board and thrown out to die on the dirt road in China, this baby girl was crying for days before she was found. When I met her a year later, I knew at once that I would dedicate her story to all the abandoned children.

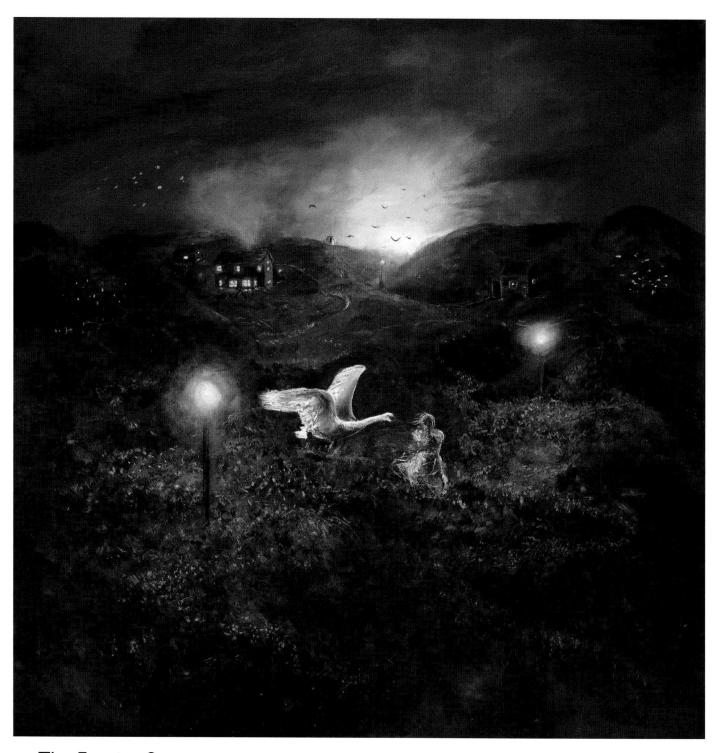

The Evening Swan • AGE 9 (acrylic on canvas; 54" x 54")

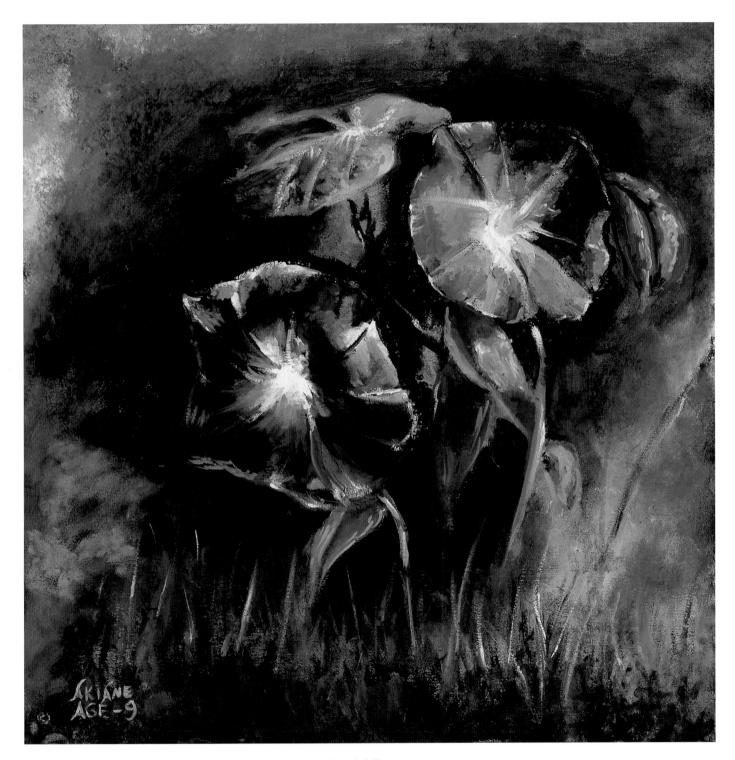

The Dance of the Mind Inside the White AGE 9 (oil on canvas; 25" x 25")

It seemed as if I painted these flowers in one breath and in one brushstroke. The oils were flowing and blending so fast until I was stopped, "Don't touch me anymore. Enough."

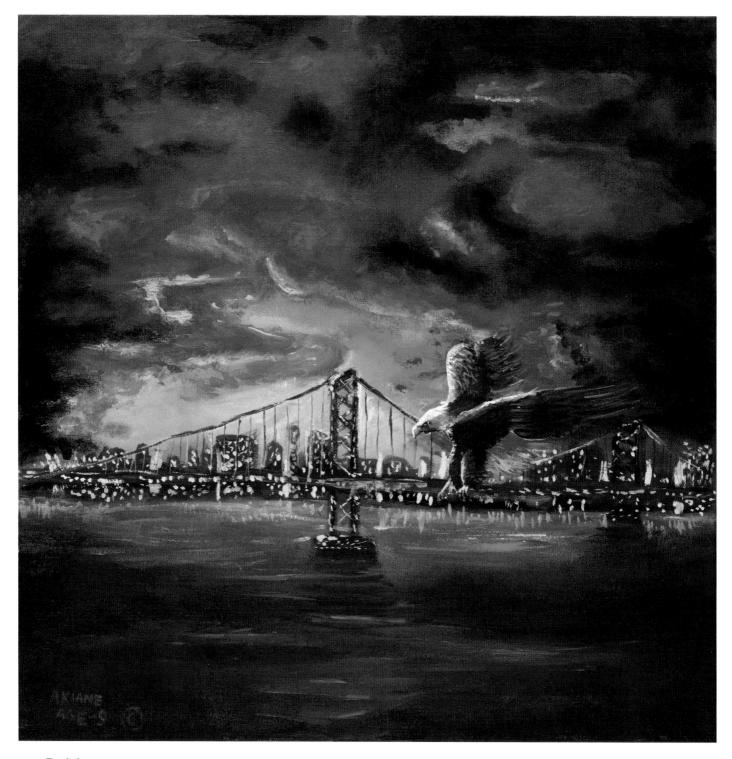

 $Bald * AGE 9 (acrylic on canvas; 25" \times 25")$

In one of my visions I saw an eagle flying through a huge city full of skyscrapers. But by the time I started painting the image, I could no longer remember the message.

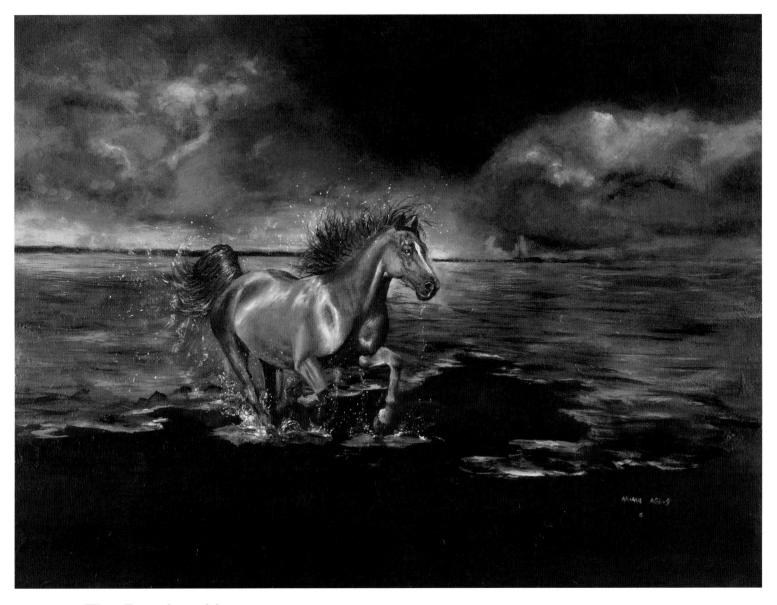

The Freedom Horse • AGE 9 (acrylic on canvas; 30" x 40")

When for the first time in my life I was invited to ride a horse on a farm, I felt such freedom! But then it occurred to me that the horse would feel free only without me on his back—somewhere in the wild. It reminded me about love: to truly love we have to be free ... to truly appreciate love we have to be free when we choose right from wrong. We can be forced to obey, but we cannot be forced to love.

The Antlers • AGE 9 (acrylic on canvas; 48" x 60")

The twenty-four deer symbolize the time—the earthly cycle of twenty-four hours in each day. Peace among families and races is represented by an entire cycle of a deer's life: from the rut and the birth up to an old age.

The Light-Bearers • AGE 9 (oil on canvas; 48" x 48")

This painting is an allegory about five groups of human beings responding differently to Truth. When the light representing the Truth shines from above, only three groups notice it. One group admires it. The second gets angry. And the third group runs away from it.

Courage • AGE 9 (acrylic on canvas; 30" x 40")

Crossing the bridge that is not even built is courage . . .

To me swans are always full of strength, grace, beauty, love, and courage. In my painting they represent people in the flight of love—the flight between people and races, the islands and the continents, the planets and galaxies is only for the brave. Maybe that's how bridges are built—crossing by faith first.

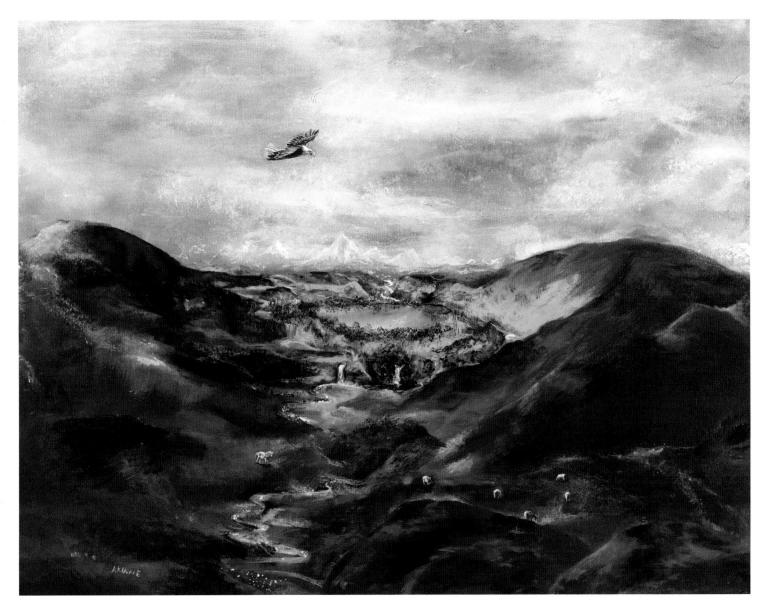

Silence • AGE 9 (acrylic on canvas; 30" x 40")

There is probably no such place as I painted here, but I wanted to show a scene that I'd envisioned in my mind for a long time. It's more expressionistic than realistic, and that's the way I wanted it to be left—a place where empty silence could also be mistaken, a place where through the sounds of nature you could hear a living silence.

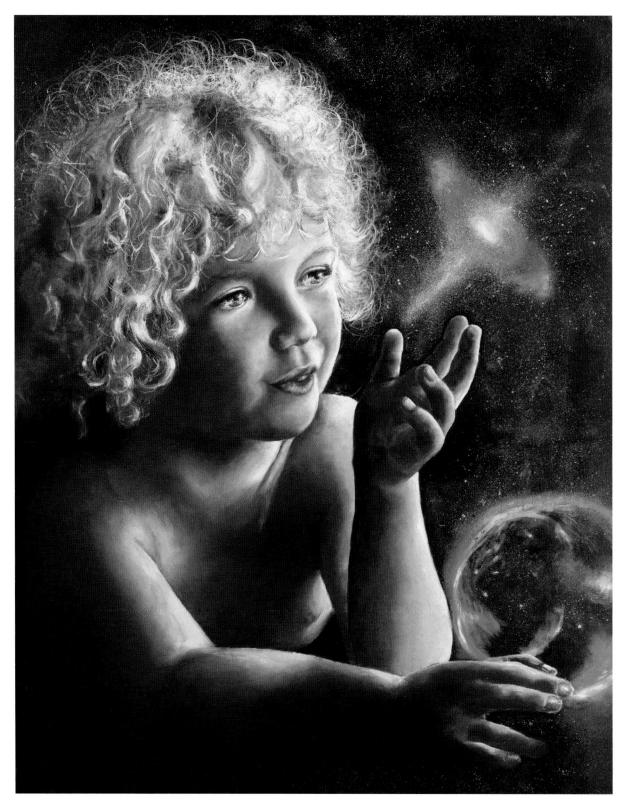

The Journey • AGE 9 (acrylic on canvas; $48" \times 60"$)

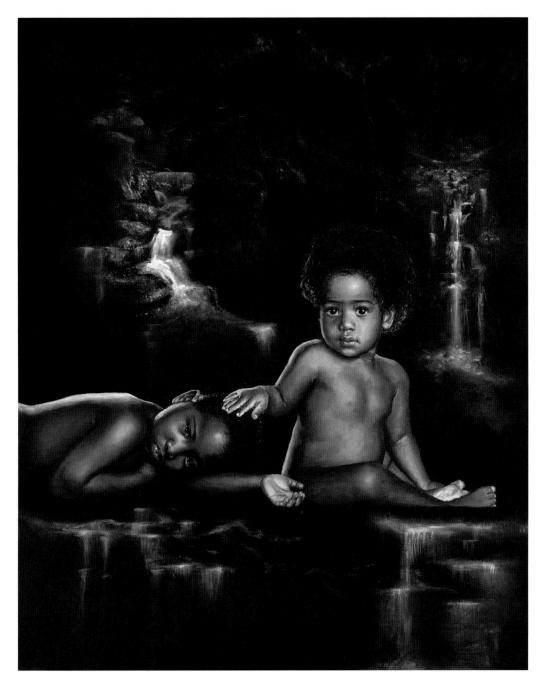

Found • AGE 9 (acrylic on canvas; 48" × 60")

I was inspired to paint all the races, but finding black people where I lived in Idaho was very difficult. After a long wait I finally met two African children whose story was so remarkable that I wanted to paint it right away. There was a taboo in their small Madagascar tribe against saving orphans, so after their parents died, the two children were taken into the jungle and left there to die. A two-year-old boy took care of his six-month-old sister for more than two months. When they were found, they were barely alive. After I invited the adoptive parents to look at the finished portrait, they cried. Everybody—including me—was surprised at the painted waterfalls in the background, because I had not known that the orphans had been found in the only waterfall jungle in Madagascar.

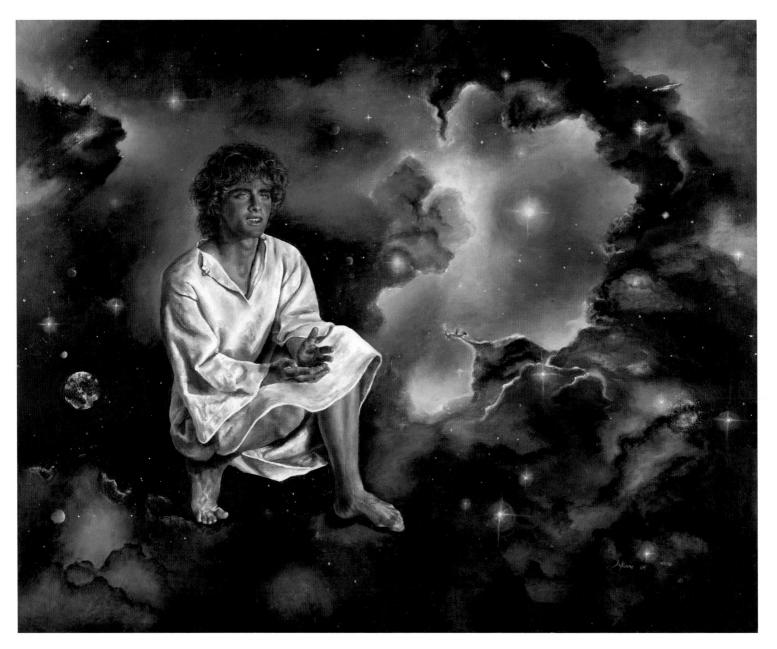

 $JeShUa - ThE \dots mlsSiNg \dots YeArS \dots \ \ \, \text{AGE 10 (acrylic on canvas; 48"} \times 60")$

The Creation • AGE 10 (acrylic on canvas; $48" \times 48"$)

The Connection • AGE 10 (acrylic on canvas; 36" x 48")

Communion, attention, and action is a true connection.

The Angel • AGE 10 (acrylic on canvas; 48" x 48")

The Power of Prayer • AGE 10 (acrylic on canvas; 36" x 48")

These birds, just like prayers seeking their destination, are flying toward the light. And unless they are humble, patient and trusting, they will not reach it. Some birds are distracted, others are playfully soaring, and still others are discouraged and turning back. Those that are terrified and lack the strength of faith crash against the steep mountains and drown in the river. The power of prayer is direction, humility, sincerity, and faith.

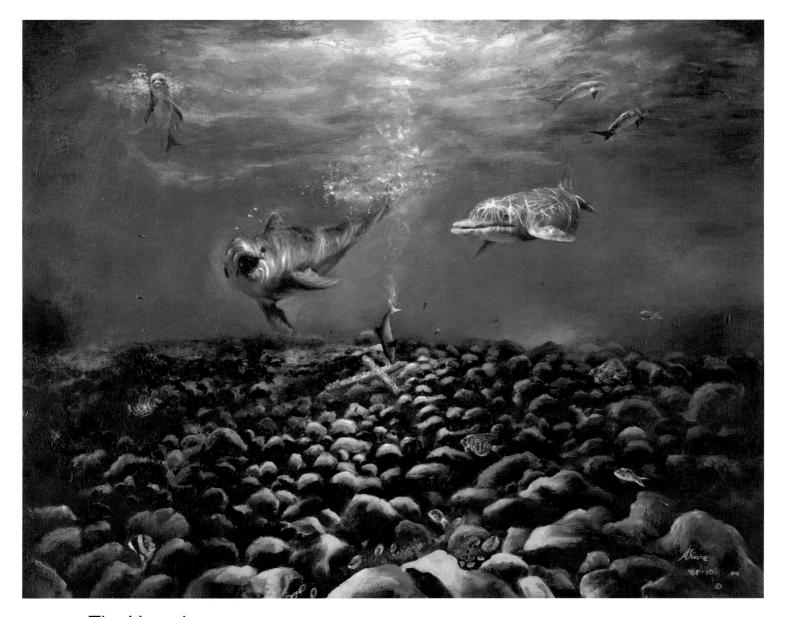

The Hourglass • AGE 10 (acrylic on canvas; 36" x 48")

The underwater light formed in the shape of the hourglass represents eternity. The bottom of the hourglass, by the rocks and open shells, represents the past eternity. While the top of the hourglass, close to the surface, represents the future eternity. The cross in the middle of the hourglass represents the code of time.

Five groups of dolphins represent five groups of beings experiencing time differently. One group swims away from it. The second one looks for time in the wrong way. The third group is distracting others from finding the secrets of time. The fourth group is being deceived and distracted. And only the last group discovers the very code of time.

AKIME

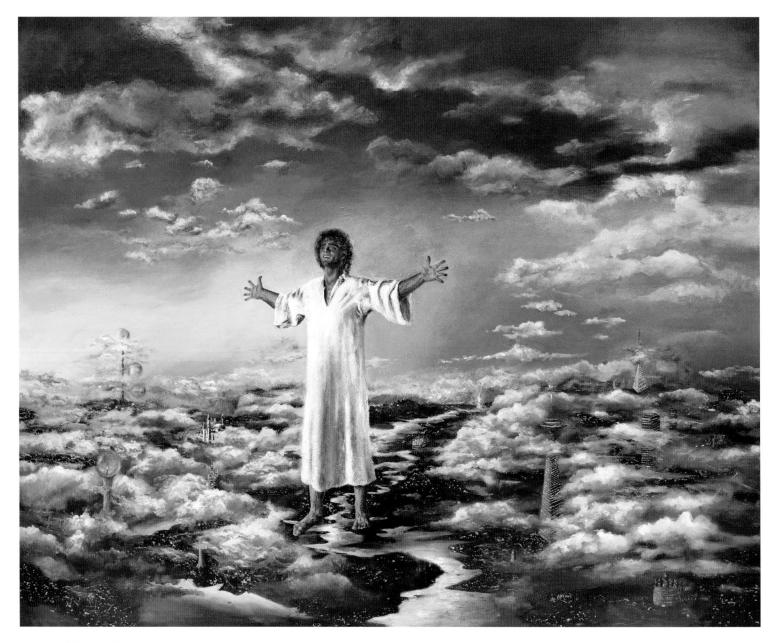

The Dreams $\, \cdot \,$ AGE 10 (acrylic on canvas; 48" \times 60")

The resurrection of consciousness is faith!

The eternal road is a narrow road where you wait for others to pass you.

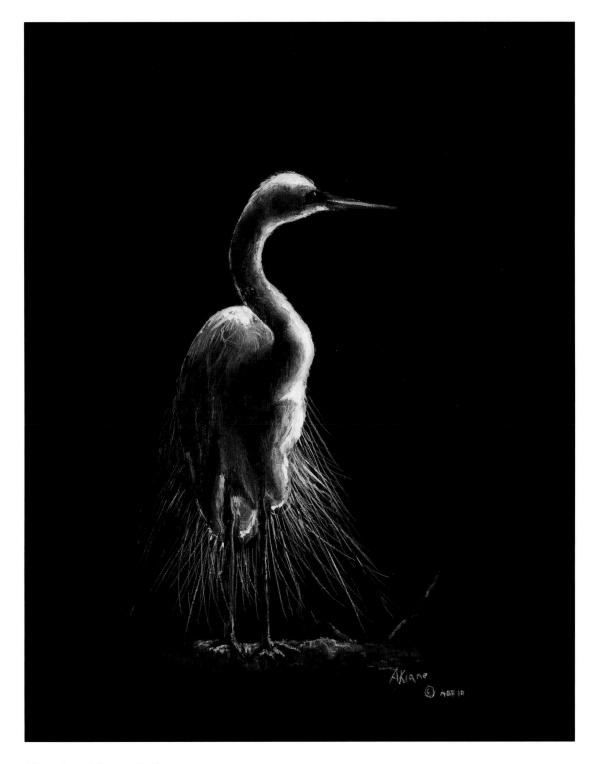

By the Moonlight $\, \circ \,$ AGE 10 (acrylic on canvas; 16" x 20")

On the ashes of a tree—an ornament.

AKIANE

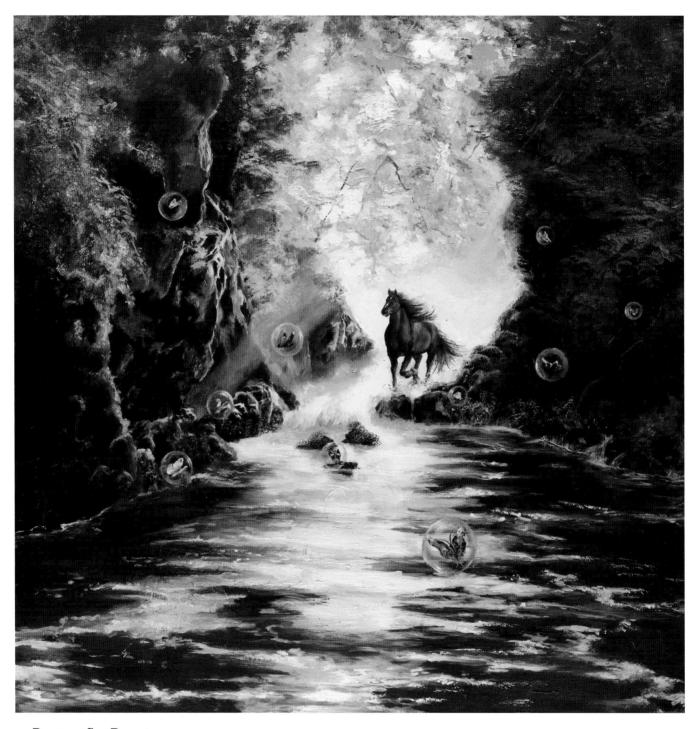

Butterfly Passion • AGE 10 (acrylic on canvas; 48" x 48")

Saddles are on their own— Everywhere we run, love flows true. Inhaling love one motion at a time I carry the river to you.

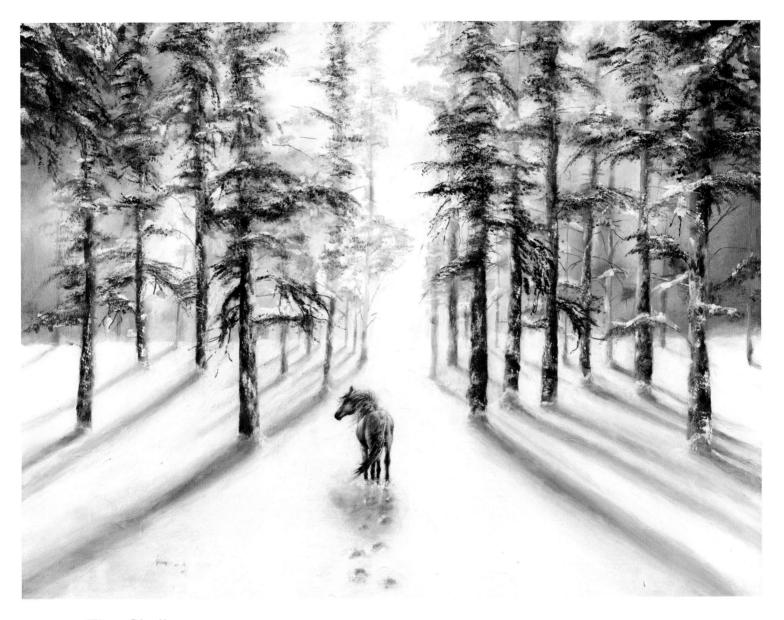

The Challenge • AGE 10 (acrylic on canvas; 36" x 48")

Which direction to choose? The challenge of the choices is a maze. The light is ahead for the journey to continue safely. But because of hunger, exhaustion, and the cold, the horse is losing its focus. The blue is the color of the mind; therefore, I painted the shadows blue to create a mental challenge and confusion.

The Forbidden Fruit • AGE 10 (acrylic on canvas; 18" x 20")

One morning I woke up earlier than usual, and right away I decided to paint—but I could not find any canvas in my studio. My family was still asleep, so quietly, still in my nightgown, I searched my art closets and found one small canvas that I'd worked on a few years ago, but later gessoed in black. I decided to paint a portrait next to a branch of fruit. Right then and there, I understood its meaning. The tree of the knowledge of good and evil is full of forbidden fruit—red for the knowledge of evil, and green for the knowledge of good, created to be appealing, fragrant, and easy to be picked. I blended all races to depict Eve, a symbol of the mother of all mankind. At first she thinks that she will gain wisdom by biting into the fruit of knowledge, but unexpectedly she finds the deception as the red poison drips out of the green fruit. The knowledge of good and evil is simply too much for a human to understand and experience.

The Pyramids • AGE 10 (acrylic on canvas; 36" x 48")

Hope $\,^{\circ}\,$ AGE 10 (acrylic on canvas; 48" \times 60")

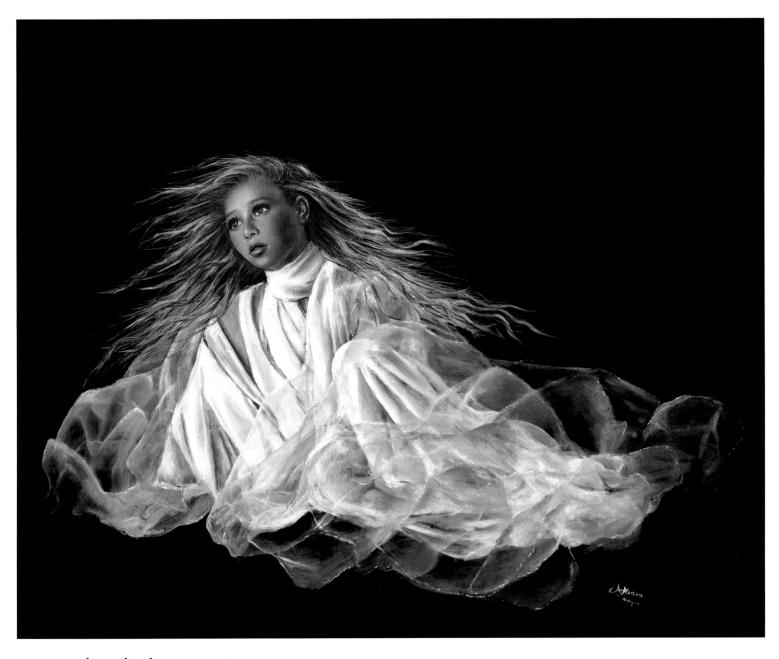

Angelic Love • AGE 11 (acrylic on canvas; 48" x 60")

Upside Down—Inside Out • AGE 11 (acrylic on canvas; 48" x 48")

"Upside Down—Inside Out" is an allegory about purpose, balance and contentment. While some plants are content with who they are and where they are, many are not. Some are artificial plants, some are real, and others are artificially real. Then there are plants growing alone or dominating weaker ones. Still others are plain and peaceful. A few see life radically different while they live upside down. Other plants are used for decoration or simply being knocked down. Some wish to be outside experiencing more changes. Outside the window some plants long to be inside the house believing it is always safe and warm there. Yet all of us, just like plants, have different personalities and purposes. We need differences that unite us, not separate. But more than anything, we need light. Without light we will wither even in the most expensive and beautiful vases.

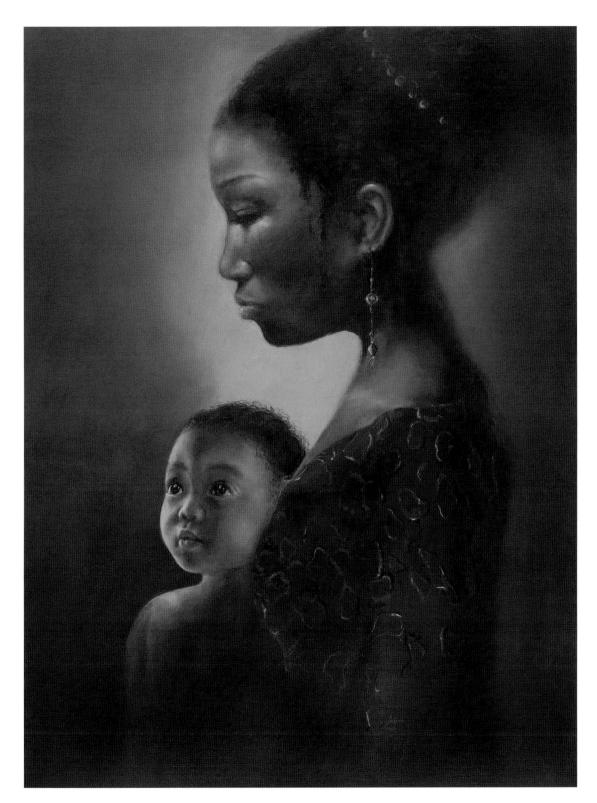

Memory • AGE 11 (acrylic on canvas; 36" x 48")

AKIME

Co-Creating (self-portrait) • AGE 11 (acrylic on canvas; 48" x 60")

Right after my eleventh birthday, I visualized my self-portrait through the view of a canvas and through the eyes of the spirit. I hoped to express the joy of co-creating, and the awe of wisdom. My palate is the universe, and I dip into the stars with my brush for colors.

akiane her poetry

	4	

The Hollow Compasses

Our thirst is drying the distance
There are no longer silent streets
It is not our eyes that see God's love
Time watches us like naked seeds

The liars are timing the truth With blisters trapped in the strife When knives of conceit divide us Who will find our forgotten life?

The doubt we paint is always a prison
The dried-up light escapes last hail
The darkness sheds its poisoned voices
With hollow compasses we sail

The Empathy

Confused by the first frost
the summer ends . . .

The hollies I picked are voices of autumn
The wooden feet are limping
by the wooden fence . . .

When I have to run I walk

Each

where each corner of the earth meets the edge of the sky purring rain surprises young summer

> as i touch every silver star i glimpse a rainbow on me Each mystery is an adventure

my feet touch a river rolled to a scroll where each wave like a runner passes me a waterlily

> Each day the sifted seeds hear the pulse of the sun yawn

Each branch holds the hurricane from running over me—
choosing love through the moss of the youth each limp is not felt like a lifetime

My Sight Cannot Wait for Me

I cannot stop holding my brush—
on the blank canvas I sign
With blindfolded balance I paint my own eyes—
Blue is the color of the mind

Do God's footprints follow His footsteps Nobody hears what I see We cannot trespass our Creator my sight cannot wait for me

The Planted Eyes

Love is my painting
Silent mountains suffer in pride
As wild spring blends the time
my breath searches heavenly mind

Blue wind surrounds the sleepy lilacs—
each sound is a sacrifice
I can hear God's whitest whisper—
Thorns have cut my planted eyes

Many Lonely Paths

White roses of hope meet together in the orchard of youth.

Straight path escapes the winding roads—

I leave home for the truth

The names I'll never know I can't forget.

Is there someone to feel I'll never see?

I cover a stranger with the first moment,
and blades of ages start sweeping through me.

Tension of battles keep wasting the truth—the wounded fall on its broken shoulders.

The unfaithful faith can't keep its own trust, if priests still faint behind the soldiers.

I'm chained in my own prophecies—
I've lived so many lives in the past!
My birth was rescued from the crowds—
the light has many lonely paths...

Soon the Divine Love will finish time, and the cross will be washed ashore...

When I'm called to return home, cold swans will shiver by my door.

The Footsteps of Spring

I wake up with the same long yawn
I fell asleep—
impressionistic footsteps of spring
catch and melt the last snowflake.

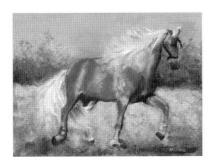

The Horse

Wildflowers stumble among the weeds, and they fall asleep dreaming the whole spring about an odd blinking eye across the half of the head.

Life Without a Leash

Yesterday's promise is today...

When a storm arrives it is time to nail a fence into our house.

Only for you the fence is open.

In the cold twilight you wait for me, and as we cuddle we both sleepwalk—

My bed is full of you...

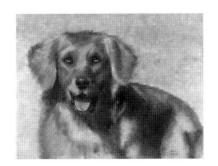

I Run—I Fall—I Dive—I See

Hiding in my own confession,
I connect to another puzzle like me.
When upside down I am unveiled by your grace—
I run—I fall—I dive—I see.

Let me go to your world where dreams are born—everything that is real or made up.

Even when I am alone the time still passes,
but when I am with you, the time just fills up.

When wrongs hurt, indifferent trees bow down to so many roads intertwined in a maze . . .

One of my eyelashes blinks without my permission—thinking of you I fly so many ways . . .

Noticing one missing feather,
I find every shade of white I still could be.
So many ways you know me...
I run—I fall—I dive—I see.

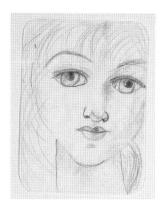

The first and the last time I saw my grandmother Aldona from Lithuania for a month was when I was four. I still remember her smile and the words she whispered to me: "I believed in God all my life, but I was afraid to share it with my family and friends. Don't repeat my mistake, Akiane. Share your faith with others. It will bring more happiness to you and to others. And never give up your passion." Although my grandma had lived through war, death, famine, and sickness, she never complained about anything. I once had a dream that she died standing and with a smile. This poem is dedicated to her.

My Grandmother

When I want to think like my grandmother, I need her cane. I need her cane.

When I want to see a flower planted by a tree,

I need the rain—I need the rain.

When a porch can no longer hold her steps,

I need to carry her—I need to carry her.

When the stiff nights no longer bow, I need to bury her—I need to bury her.

When a ladder swings on a swing,
I need to climb—I need to climb.
When her crocheted linen scarf unravels,
I need the time—I need the time.

When her garden is filled with the skylarks,
I need to pray—I need to pray.
When the rest has no trust in the ground,
I need to stay—I need to stay.

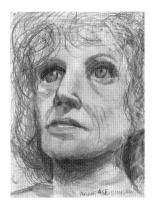

The Raking

Next to rabbit holes, around the wind-kissed blossoms, summers are born to hatch eggs in the nest. Again I am too slow watching the grass grow, and the autumn again is here to rake me.

The Anthill Ashes

When life lies down on the song of a bird I step inside the anthill ashes...

My cross is nailed into me...

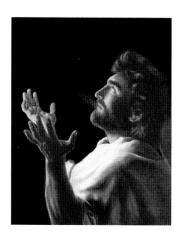

Again I Find the Winter

I cannot find any reason to be in the snow.

As shadows of winter colors hold me a breath of desire is so still—

The handmade cast molded for eclipsed love is fading the prime...

Looking for summer in the falls of the spring, again I find the winter.

It's Not Too Late

Perhaps I wanted to catch it. Perhaps not. But one morning I wanted to paint the wings— Too late—they flew away. I wanted to paint a flower— Too late—it withered. That night the rain was running after me. Each drop of rain showed one and the same face, and it was everywhere. I wrung out the love to make the red. I wrung out the stumps to make the brown. I wrung out the trust to make the yellow. I wrung out my own eyes to make the blue. I wrung out the leaves to make the green. I wrung out the nightly pain to make the black. I wrung out my grandmother's hair to make the gray. I wrung out my visions to make the violet. I wrung out the truth to make the white.

Today I want to paint God's face—
it's not too late.
IT'S NOT TOO LATE

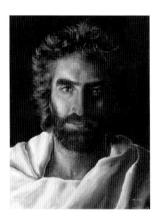

The Clematis Dream

We enter a meadow and play hide and seek.
We run so fast that sunlight cannot catch us.
Life seems longer when you jump in the grass.
Without the reins.

The vines of clematis seem to be planted in the air.

Should we grow up like that?

I gather the fallen petals, plant a seed bigger than the whole garden,

and water for two.

My brother slips and falls down on the dirt.

It is so foggy, no one sees him.

His muddy boots in the fog do not look so muddy after all.

When I run, my eyes are closed,

and I bump into the childhood tree with a hammock full of the clematis pollen, where the hummingbirds land. And that is all I remember from my dream.

I am only a child, but I remember everything I need.

Everything I know is someone. Everything I think is someone.

Love was created to create.

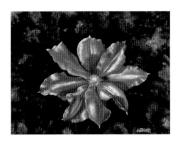

Silence

With each silent mask, with each silent way silence can also be mistaken.

Sometimes dreams fall like raindrops from the very eye of the storm...

Holding onto the antlers of the spring, like onto the spasms of the future,

I blow wild feathers in the wind.

With each silent mask, with each silent way silence can also be mistaken.

The Evening Swan

You need to cleanse and silence your eyes, for dizzy prayer bounces off a wall.

All of your doubts land on a silent swan—

You need her love to catch you when you fall.

Brassy visions count each and every stone—there are so many lives in this lonely womb.

When feelings are hungry mirrors show different faces.

The only evening the swan lands she looks for you.

The Dance of the Mind inside the White

As time climbs up a storm in a single breath, stars stare strangely at us, and laurels rest between twin winners.

Which world searches for us while the dew drops gently roll down our cobalt blue petals?

The Journey

Walking through a poppy universe,

I rattle the hourglass isles.

Where the time sings in the crossroads of hope,
I am a brush painting for miles.

Balancing myself on just one finger, at first I think that everything is white. From universe to universe I jump alone just to find out that I'm still a child.

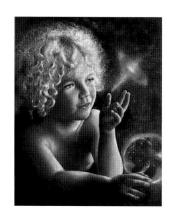

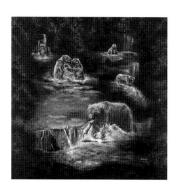

The Light-Bearers

The light from above separates the waterfalls...

The berries fall into the salmon river—the breeding season is long past...

The Freedom Horse

A wild stallion saddles the ebony sand without missing a wave.

Every wave is a short serenade.

Every gallop is a purpose.

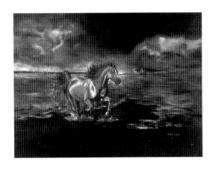

Tulilips

The motion of a child's cry is deeper than any emotion—
like an iceberg, it drifts away from home, leaving the dreams of song landscapes alone.

Beneath a pulse of memory—
a journey of the tulilips.

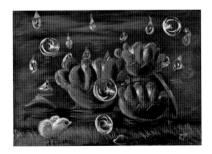

The Summer Snow

Clouds move for miles, but I cannot find the white in any other color. Rescuing the blossoms from the summer snow, suddenly I feel a touch.

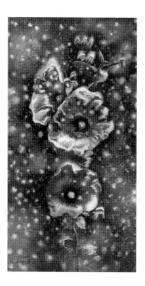

Норе

The war in the soil.

The seeds are too young to fight.

But the guilty still feel no remorse.

Across the harvest of blades improper desires wrinkle the childhood. Without any cries and without any touch the cradles are left behind.

Inside each fragrant branch the pain of wisdom—
colors of love.

Acknowledgments

My BIGGEST THANKS go to my family, who believed and supported my dream. Without my mother's loving patience and encouragement; my father's humor, energy, and loyalty; my older brothers' devotion and attention to the family's daily needs; my youngest brother's sensitivity and imagination; and my angels' selfless guidance, I would not be where I am today, and this book would never have been written.

I have special thanks for the relatives, friends, and acquaintances who inspired our family the most through both hard and easy times. There were those who encouraged us to homeschool. There were those who helped us when we were penniless. There were those who were instrumental in our spiritual growth. There were those who appreciated my art and poetry. There were those who understood the reality of my visions, and those whose faith and optimism were infectious, carrying us through very turbulent times. There were those who motivated us to write the biography. There were those who offered us shelter in their huts or mansions. There were those whose prayers brought miracles. There were those who shared our everyday lives, helping us to grow: Johana Koeb, Aldona Blisntrubiene, Vladas Blinstrubas, Stanislava Simutiene and her entire family, Alfred Guscius, Renee and Brent Caudill and their family, Amber Spring and her family, Sandy Ross and her family, Caroline Faber, Natalie Camino, Charles and Lauren Bisbee, Bob and Rhonda Beckman, Sheila and Mark Hubert, Chris Leonard, Steve and Sandy Charbonneau, Ilana Goldman, Kay Drumright, Debbie Heil, Buffy, Mary Cunningham, Susan Badell, Moe Segal, Linda Czir, Bill Wigley, Sylvia Castle, Dawn and Ross Radandt, Paul Keith Davis, Michael Lloyd, Susan Miller, Mirian Trobridge, Dubrava Pochernikova, Marina Koledintseva, Mathew Block, Ernest Moyer, Roger Jellinek, Rolla St. Patrick's School, and many others.

I also want to thank all the art students I've taught, wonderfully patient models who modeled for me, churches, galleries, and museums that invited me, photographers, cameramen, and media who allowed me to share my dream with others, fans who supported me with their letters, gifts, and smiles, many charities, especially the LISTEN campaign, Free the Kids, and Northwest Medical Teams for giving me an opportunity to help sick and poor children around the world.

My thanks go to all art collectors, but especially Brian and Susan Conrad, Steve and Abby Appelt, Sylvia and Richard Witt, Emory Miller, Holly and Daryl Robertson, Margaret Mills, Jerry Fuhs, and Whitey and Fran Menching.

I also want to thank those who were the most supportive and helpful in bringing my art and poetry to millions of people: Debbie Wickwire (acquisitions editor, Thomas Nelson), Chris and Linda Gibbs (the reproduction printer), Karl Knelson (webmaster), Victoria Nesnick (president, Kids Hall of Fame), Emily O'Donnel (reporter, *Time* magazine), Paul Keith Davis (the speaker), Rick Hankock (ABI), Oprah Winfrey and her producers (*Oprah*), Robert Schuller (*Hour of Power*), Marjorie Neufeld (Miracle Channel/Life Line), Patricia King (Extreme Prophetic), Alyson Marino and Craig Ferguson (*Late Late Show*), Gary Dini (FOX magazine), Wayne Brady (comedian, host, *Wayne Brady Show*), Lou Dobbs (CNN), producers at *Good Morning, America* and *World News Tonight*. Many thanks to all television and radio stations, magazines, and newspapers around the world who shared my story.

Index

(Artwork titles appear in italics; poetry titles appear in quotes.)

Again I Find the Winter, 46
"Again I Find the Winter," 99
Akianism, 36
Angel (drawing), 9, 96
Angel, The, 75
Angelic Love, 85
"Anthill Ashes, The," 98
Antlers, The, 66

Bald, 64 Butterfly Passion, 80 By the Moonlight, 79

Challenge, The, 81
"Chipped View," 24
Clematis Dream, The, 51, 101
"Clematis Dream, The," 101
Co-Creating, 88
Connection, The, 74
"Conversation with God," 21–22
Courage, 68
Creation, The, 73
Crystal Cathedral, 34–35

Dance of the Mind Inside the White, The, 63, 103 "Dance of the Mind Inside the White, The," 103

dancing, 11–12 Dobbs, Lou, 30 Dreamfence, The, 47 Dreams, The, 78

Each, 48
Eagle, The, 48
Empathy, The, 43, 91
"Empathy, The," 91
Eve, 82
Evening Swan, The, 62, 103
"Evening Swan, The," 103

Faith, 61
Father Forgive Them, 28, 56–59, 98
Footsteps of Spring, The, 46, 95
"Footsteps of Spring, The," 95
Forbidden Fruit, The, 82
Found, 71
Freedom Horse, The, 65, 105
"Freedom Horse, The," 105

God
as inspiration, 30
visions of, 7–8
Growth, The, 44, 94

gymnastics, 11	Kramarik, Ilia, 15, 16, 17, 32, 35		
heaven, 10-11, 12	photos of, 15, 38		
Hollow Compass, The, 43, 91	Kramarik, Jeanlu, 4, 14		
"Hollow Compasses, The," 91	photos of, 14, 38		
Hope, 84, 107	Kramarik, Markus, 3, 4, 5, 6, 7, 11, 12–13, 14, 15, 16,		
"Hope," 107	18, 20, 24, 29, 32		
Horse, The, 47, 95	photos of, 6, 38		
"Horse, The," 95			
Hourglass, The, 77	Life Without a Leash, 53, 95		
house of Light, 10-11	"Life Without a Leash," 95		
	Life, The, 43		
"I Run—I Fall—I Dive—I See," 96	Light-Bearers, The, 67, 104		
"It's Not Too Late," 100	"Light-Bearers, The," 104		
	Listening, 52		
Jeshua—The Missing Years, 72	Lou Dobbs Show, 30		
Journey, The, 30, 70, 104			
"Journey, The," 104	"Many Lonely Paths," 94		
	Missing Years, Jeshua—The, 32–33, 72		
Kids Hall of Fame, 37	Museum of Religious Art, 35–37		
Kramarik, Akiane	music, 12		
as binary prodigy, 37	My Grandmother, 97		
birth of, 3	"My Grandmother," 97		
as chosen, 33–34	My Mother, 10		
dreams and visions of, 7-20, 21	My Sight Cannot Wait for Me, 55, 56, 93		
early drawings, 9–13	"My Sight Cannot Wait for Me," 93		
early paintings, 15, 20, 25			
early poetry, 16-19, 21-24	Oprah Winfrey Show, The, 29–30		
first years, 3–7			
injuries, 4, 16	paintings, expressionistic, 25, 50		
languages, 16, 19, 30	Planted Eyes, The, 54, 93		
naming of, 3	"Planted Eyes, The," 93		
photos of, vii, 3, 5, 6, 7, 8, 13, 14, 15, 20, 28, 36,	Power of Prayer, The, 76		
38, 56, 57	Prince of Peace: The Resurrection, 25-28, 36, 56-58, 100		
teaching of art to others, 25	Pyramids, The, 83		
vocabulary of, 5, 8, 18			
works of other artists and, 25	Rainbow River, The, 44		
Kramarik, Delfini, 4, 9, 16, 17	Raking, The, 45, 98		
photos of, 15, 38	"Raking, The," 98		
Kramarik, Foreli			
photos of, 8, 13, 15, 38	"Searching for Rainbows," 17		

self-portraits, 55, 56, 88, 93 Shroud of Turin, 28 Silence, 69, 102 "Silence," 102 "Stage, The," 30–31

Strength, 49 Summer Snow, The, 60, 106

"Summer Snow, The," 106

Tulilips, 50, 105 "Tulilips," 105

Upside Down—Inside Out, 86

Victoria (Armenian woman), 4

Waiting, The, 45

Winfrey, Oprah, 29-30

Wright, Frank Lloyd, 6–7

Testimonials for Akiane

"Akiane is a gifted and seasoned artist who is totally focused on her work. She is a renowned prodigy in the arts world!"

WORLD NEWS TONIGHT, ABC

"We have been collecting the paintings by Salvador Dali, Picasso, Marc Chagall, Miro, and now—Akiane!!!"

STEVE AND ABBY APPELT, Art collectors
United States

"To say that Akiane has extraordinary talent is a gross understatement. She is a young genius and a spiritual young lady with an amazing gift who is changing the lives of all who have come into contact with her."

FOX MAGAZINE/FOX NEWS

"Nothing has prepared us for this nine-year-old who has mastered the art of realist painting."

LOU DOBBS SHOW

CNN

"I see Akiane's paintings or read her poetry and it's very clear to me that God is with us, and He's close by. So very clear."

MICHAEL LLOYD

An Award-Winning Music Producer and Composer

"We believe Akiane's paintings were not merely divinely inspired, but divinely commissioned! We are honored and blessed to be the caretakers of "The Light Bearers." Their story is our own journey of faith. Akiane is fearless on the canvas. This painting is a beautiful expression of the Father's love."

Susan and Brian Conrad Art Collectors, Canada

"Akiane is a sign of the times. What an incredible artist and poet!"

LIFELINE/MIRACLE CHANNEL, Canada

"What an amazing and talented young girl!!!"

CRAIG FERGUSON, The Late Late Show

"Akiane, you are an incredible young lady! We thank you for using these precious little hands to do incredible work for God. Absolutely spectacular paintings! God loves you and so do we."

ROBERT SCHULLER, Hour of Power, Crystal Cathedral Garden Grove, California

"Akiane's innocence, her vision, passion, and compassion all come through in her paintings and poetry. I believe this young and gifted artist is destined to leave her mark in the world of art."

EDWARD SOLOMON
Co-Founder and Director of the International Museum of 21st Century Art
(TIMOTCA), Art Beyond Borders
Laguna Beach, California

"Akiane is a beautiful name in itself. However, you have to meet this ten-year-old artistic prodigy in person to see her beauty and the beauty of her art to appreciate her phenomenal talent! My wife and I have recently had the privilege of going to her home in Idaho and meeting the young lady and her lovely family. To say the least, we were astounded! To see her realistic paintings first-hand and to encounter her simple demeanor was the thrill of a lifetime!"

H.E. WHITEY MENSCHING Collector and Assistant Curator, The Museum of Religious Arts Logan, Iowa

"Akiane's strikingly realistic paintings, drawings and poetry are windows into the soul of her subjects, reaching a depth far beyond her years. Her captivating works create a powerful and lasting impression, rivaling the works of many adult artists. Akiane's unique achievements have earned her an induction into The Kids Hall of Fame."

VICTORIA NESNICK, Ph.D. Founder, President and Publisher, The Kids Hall of Fame

"Akiane is unique. She is a phenomenon. I have never seen an artist with such a unique gift as this young lady has, with absolutely no training at all. She produces some of the finest works of art I've ever seen."

MICHAEL O'MAHONY President and CEO, Wentworth Galleries

"It seems that these expressions are not those of a young girl but of a mature poet whose aphoristic and enigmatic thinking come to her instantly. Hers is definitely a philosophical poetry, and our world literature can be so proud of this new *wunderkind* genius."

ALFRED GUSHCHIUS
Renowned Lithuanian Literary Critic and Poet

"Akiane is a literary phenomenon in the history of poetic art. I doubt there has ever been a literary child genius of such maturity, lyrical virtuosity, and spiritual transcendence! Her rare gift will be engraved forever in the history pages of the world's literature. I see the cosmic hope and meaning of life in her wisdom-saturated imagery. I am speechless!"

VLADISLOVAS BLINSTRUBAS Distinguished Lithuanian Poet

"I have never encountered such talent for painting in anyone so young. Akiane's poetry is even more impressive than her painting. Her images are astonishingly mature and original: fearless, deep, and mysteriously powerful. Yet Akiane herself remains an unpretentious, unselfconscious, delightfully unaffected and playful ten-year-old girl!"

ROGER JELLINEK Literary Agent and Editor

"Akiane is an absolute artistic prodigy! Her creation electrifies with the realism, the artistic sense, and the level of mastery, spectacular even for an adult artist. When I was first acquainted with the petite Akiane she was only five, and even then she amazed everyone with her abilities. I still to this day treasure the pencil sketches, including my portrait and a squirrel—live as live can be—that she gave me as a gift."

Marina Koledintseva, Ph.D. Professor, University of Missouri

"Fantastic works! I was impressed by her flowers. They are absolutely real and full of childhood soul. Without any argument or doubt, Akiane is great!"

Victor Depuev

The Academy of Sciences of Russia, Moscow

"We have known Akiane and her family for several years, since she was four years old, enjoying a close and rewarding relationship which we have been thankful for. To us she always seemed like a normal, happy little girl, apart from her very advanced and beautiful works displayed at home in Missouri, and a strong interest in spiritual things uncommon for a child."

Renee and Brent Caudil, M.D.

"My wife and I have always been in awe of the talent that comes from just the slightest stroke of a brush and the thoughts of an inspired and truly gifted artist, but no other has touched and captured our family's heart, soul, and imagination more than that of Akiane. Not only is she a rare diamond artistically (an understatement), but most importantly she's a sweet angelic little girl who has the heart and ability to touch the world for the less fortunate, and through her hands, make it a truly better place. For this reason, her gift is invaluable and long awaited."

MICHAEL WARD, M.ED., Psychotherapist
EMILY WARD, CEO and President,
Le Triomphe, Inc. Intl

"I observed Akiane at school in Colorado and I knew her also as a personal friend. A precocious seven-year-old with an enthusiasm for living, she was a beautiful child with a strong faith in God already evident in her young life. I enjoyed watching her romp and laugh with their family's golden retriever in her yard at home. She had a unique art ability already displayed in her paintings at such a young age! She has truly grown into a self-motivated, talented young woman with the same attributes I observed in her as a young girl. Akiane's zest for living and her sense of humor make her a delightful individual. I see so much faith through her unique paintings. It has been a true pleasure to know Akiane. I thank God for showering His gifts on someone who will share them with the world."

SYLVIA CASTLE, M.ED.

Teacher

"Akiane's use of color, balance and execution are usually reserved for masters three to four times her senior. Her genius is her ability to absorb the world around her and translate exactly what she sees in perfect form."

RICK HANCOCK, President/CEO, ABI, Art Dealer and Publisher

For more information about Akiane,

her art and writings,

SEE www.akiane.com

OR CALL I-800-318-0947.

To Antonella, Giovanna, and to Enrichette. M.D.C.

First American Edition 2016 Kane Miller, A Division of EDC Publishing

Text and illustrations © EDT srl Torino, Italy, 2015

Originally published in Italy by EDT srl under the title, "Amelia che sapeva Volare."

All rights reserved. No part of this book may be reproduced, transmitted or stored in an information retrieval system in any form or by any means, graphic, electronic or mechanical, including photocopying, taping and recording, without prior written permission from the publisher.

For information contact:
Kane Miller, A Division of EDC Publishing
PO Box 470663
Tulsa, OK 74147-0663
www.kanemiller.com
www.edcpub.com

www.edcpub.com www.usbornebooksandmore.com

Library of Congress Control Number: 2015954200

Manufactured by Regent Publishing Services, Hong Kong, China Printed December 2020 in ShenZhen, Guangdong, China

8910

ISBN: 978-1-61067-469-0

Written by MARA DAL CORSO . Illustrated by DANIELA VOLPARI

Kane Miller
A DIVISION OF EDC PUBLISHING

My name is Amelia.
I am ten.
Someday, I'm going to fly.

I have a scrapbook.
I've filled it with pictures and stories of women who have done great things.

Someday, I will be in someone's scrapbook.

I climb rocks, open my arms ... and take off!

I am flying.
Everything looks so small from up here.
I feel the wind.
I feel like I can fly forever.

I remember the first time I flew.
I crash-landed and hurt my knee, but it was worth it.

My uncle helped me build a launchpad. One, two ... three!

Then I see it – an airplane coming out of the clouds. It's so far away.

It's even higher than the roller coaster.

My name is Amelia.
I am ten, and I am ready to take off.
Someday, I will be in a scrapbook.
Someday, I will fly.

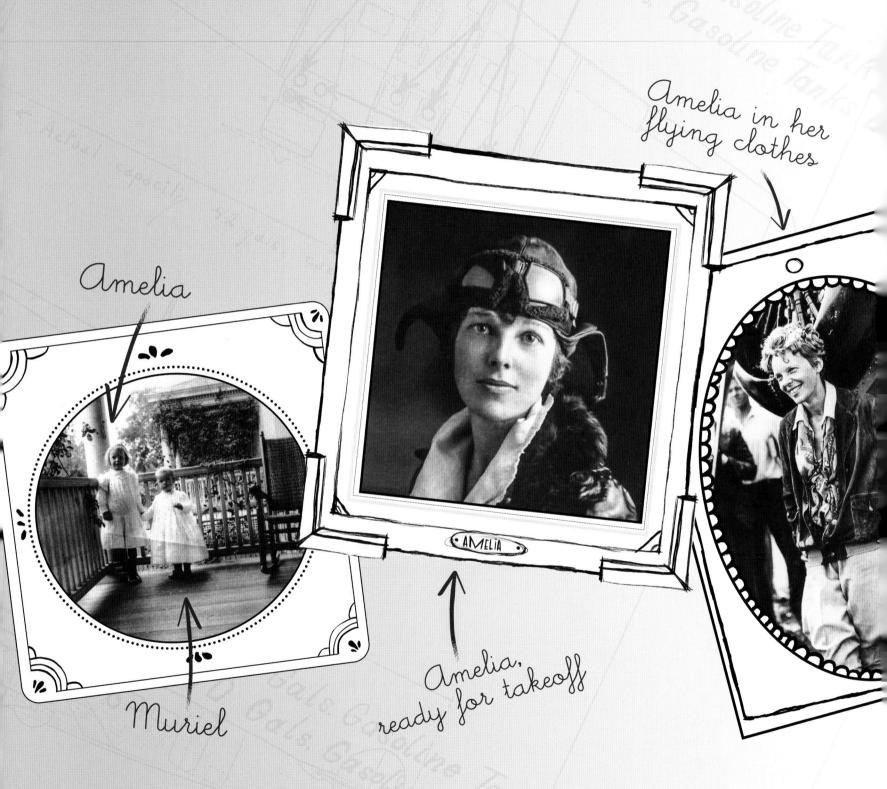

Anelianart

Amelia Earhart was born in Atchison, Kansas, on July 24, 1897 and spent her childhood in both Kansas, with her grandparents, and Iowa, with her parents.

A nonconformist from an early age, as a child, Amelia and her sister, Muriel, roamed the fields, collecting frogs, hunting for moths and exploring. Amelia liked to wear pants (quite unusual for a girl at that time!) and wanted her hair cut short.

When Amelia was seven years old, she built a ramp on an old toolshed, and, with the help of her uncle and an old wooden box, tried to fly. She ended up with skinned knees, but that didn't stop her! Thoughts of flying filled her head, her body, and her heart, as she said much later. Seeing an airplane fly for the first time at the state fair just made her even more determined to learn.

Amelia received her first plane as a gift for her twenty-fifth birthday. She painted the plane yellow, and named it "Canary."

From then on, there was no stopping Amelia! Newspapers and fashion magazines followed her remarkable flying career and often published photos and stories. Amelia even designed her own clothing line!

Amelia Earhart was the first woman to cross the Atlantic Ocean flying solo, in 1932. She disappeared, somewhere over the Pacific Ocean, in 1937 while attempting an around-the-world flight.